SONGS OF BLEEDING

by

SPIDER

BLACK THISTLE PRESS
NEW YORK CITY 1992

PUBLICATION CREDITS

"Song of the Bleeding Shaman's Journey" first appeared as "Blood of My Ancestors" in the Summer Solstice issue of *SageWoman Magazine*, 1988.

An early version of the ceremony "Snake Dance and Spring Planting Ceremony," in the chapter "Song of the Spring Equinox," first appeared in the article "Spring Planting Rite," published in the Spring Equinox issue of *SageWoman Magazine*, 1989.

"Song of the Sacred Tree" was first published by *Moonbreath*, the newsletter of the Caney Indian Spiritual Circle, Spring, 1990.

"Song of Each New Sun" and "Song of the Blood Lodge" both appeared in the Summer 1990 publication of *Moonbreath* by the Caney Indian Spiritual Circle.

The song "My Sister the Moon" was published in the Spring Equinox issue of *SageWoman Magazine*, 1990

Cover and text printed on recycled paper
Manufactured in the United States of America
Printed by Braun-Brumfield, Inc., Ann Arbor, Michigan

ISBN 0-9628181-3-5

BLACK THISTLE PRESS
491 Broadway
New York, N.Y. 10012
(212) 219-1898

ACKNOWLEDGEMENTS

I would like to honor two of my teachers who have provided inspiration, motivation, and support for my work of drawing together the Sacred Web of Life. My gratitude goes to Twylah Nitsch, Elder of the Wolf Clan Teaching Lodge, and Miguel Sagué, Chief Beike of the Caney Indian Spiritual Circle.

Taino Ti and many thanks to Tenananche Semiata-Akuaba for her beautiful illustrations of the Food Mothers' masks and cover painting.

Much love and appreciation to Jessica Coville who spent many hours editing, typing, and encouraging my completion of this manuscript. Also many thanks to Shooting Star for her wonderfully efficient typing and computer work. To Josie Byzek, my thanks for helping with the initial editing and reading the manuscript. To my neighbor, Claire Lytle, much appreciation for sharing her proofreading skills. My photo on the back cover is credited to Annette Alberth, much love and thanks for her work. Thanks to Martha Gorzycki for design assistance. And to the Caney Circle Clan Mothers and all the other women who helped in any way with the completion of this vision, Taino Ti.

CONTENTS

CELEBRATIONS & CEREMONIES

CREDITS

The following ceremonies and teachings are from the Taíno tradition as followed by the Caney Indian Spiritual Circle, except for SONG OF THE EARTH CHANGES.

PART 2:

SONG OF THE EARTH—Taíno creation story

SONG OF THE SACRED WORDS—Caney Circle Sacred Words

SONG OF THE MEDICINE WHEEL—Taíno Medicine Wheel Teachings

SONG OF THE EARTH'S CYCLES—Caney Circle Clan Mothers' Teachings

SONG OF THE SPRING EQUINOX—Snake Dance and Spring Planting Ceremony, Caney Circle Women's Ceremony

SONG OF THE SUMMER SOLSTICE—Purification Lodge Ceremony, Caney Circle Women's Ceremony

SONG OF THE FALL EQUINOX—Snake Dance and Thanksgiving Ceremony, Caney Circle Women's Ceremony

PART 3:

SONG OF CELEBRATION—Caney Circle Women's Lodge Ceremony

SONG OF NEW LIFE—Ceremony of Welcoming Spirit Life to the Earthwalk, Caney Circle Clan Mothers' Passage Rite Ceremony

SONGS OF THE CHILDREN—Ceremony of Welcoming a Newborn Child and Children's Naming Ceremony, Caney Circle Clan Mother's Passage Rite Ceremonies

SONG OF TRANSFORMATION—Community Ceremony of Honoring the Dead, Caney Circle Ceremony

PART 5:

SONG OF EARTH CHANGES—was inspired by the teachings of the Wolf Clan Teaching Lodge. Further information about the teaching of Earth changes can be found in *Other Council Fires Were Here Before Ours* by Twylah Nitsch and Jamie Sams, Harper/San Francisco, 1991.

ILLUSTRATIONS

PART FIVE

All borders were inspired by Taino pottery designs and made
by Spider.

EDITOR'S NOTE

The name Spider certainly befits the author of this amazing text! Through weaving delicate and resilient threads of history and song together, Spider provides a beautiful pattern of remembrances; the earthy lyricism of Women's Mysteries.

For so long, women have been defined by that which is outside of them. Cultural perpetuation of certain ideals has led most of us to resent our own gender; feeling dirty about our bodily functions and in general, seeing ourselves as second-class citizens. As the advertising industry is a great barometer of this, all we need to do is witness the multitude of "feminine-hygiene" products, make-up, perfume and diet-aids that are littering our store shelves and landfills.

Upon approaching the responsibility of editing this book, even with years of studying women's issues, the content seemed so over-whelming—to establish a special space and special ceremonies for honoring menstrual cycles! Social conditioning had seeped in further than I imagined.

The process of watching this book unfold has been a journey in itself; recalling history, redefining the present and dreaming the future.

You now hold in your hands a very powerful book. Its vivacity comes not in attempting to create an exclusionary society, but in the reclaiming of women's personal bleeding medicine. Simply, it's a discovery of the power within as a woman.

Coming through the Blood Dreams and teachings of our sister, Spider, you will not be able to forget this book. For this text will help you remember your greatest gift on this Earthwalk—your blood.

Jessica Coville
March 1992

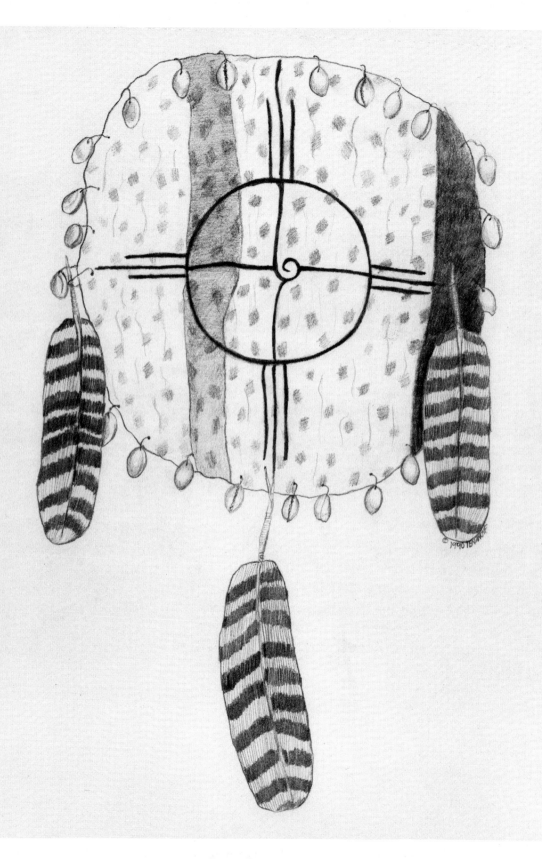

PART 1

SONGS FROM THE WEB

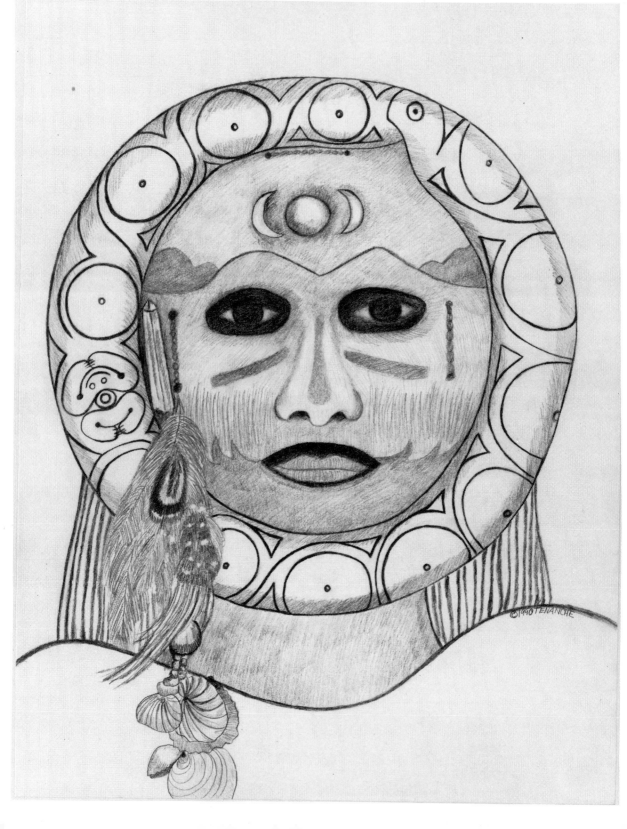

SONG OF EACH NEW SUN

With honor I greet this new day
Great Mystery, I thank you for all of my gifts
Mother Earth, I thank you for honor of sleeping and walking on your breast
Brother Sun, I thank you for returning your warmth and light this day
Sister of the South, I thank you for the beauty and laughter you bring today
Sister of the West, I thank you for the dreams and visions of the night
Sister of the North, I thank you for the lessons and teachings you bring today
Sister of the East, I thank you for the inspiration of my being here today
Grandmothers, I thank you for your guidance as you speak through my
womb cycle today
All my relations, I honor your presence in this world we share together
I give only kindness and love to all that I meet today

SONG OF MYSELF

I am one
who shares energy with trees
growing roots deep down into the Womb of the Mother
I am connected and balanced

I am one
who creates things of beauty
and heals all the hurts
of all the life that is the Earth

a daughter of the Earth Mother
I walk my path
in peace and harmony
with love for all
I dedicate my work

SONG OF THE CHRONICLE SONGS

In ancient times, before writing was common, events were recorded through songs. Sitting by the fires in the evenings, each tribe or community remembered events that occurred through singing the "chronicle song." Births, deaths, marriages, seasonal changes, celebrations and special hardships were the verses of the community song. Each verse was like a chapter of a story, telling of one activity in a series of events that affected the growth of the tribe or community. These songs had many verses and could last for hours or even days.

There were also chronicle songs that told of the wisdom of the Ancestors and preserved the sacred knowledge of healing as well as rites of passage ceremonies. These songs were perhaps sung during special ceremonies to initiate new keepers of wisdom and were the vehicle through which the sacred knowledge could be remembered and passed down to future generations.

When visitors arrived, or when tribes or communities gathered together, the chronicle songs were the way that information was shared. Entire histories were sung by the people around the fires. The songs of wisdom were continually changing, as new experiences and knowledge became part of the verses.

I have chosen to use the format of the chronicle to present this wisdom given to me by the Ancient Grandmothers. At this time, our

Mother Earth is in need of new keepers of women's wisdom so that the Bleeding Lodges may again come together. The songs I share here tell the story of Women's Wisdom that comes from our wombs and the rites of passage that attune our lives with the larger cycles of the Mother. I sing them through the pages of this book so that the sacred knowledge can be remembered and given to our daughters. These songs, too, will change and grow, as the Bleeding Lodges return to bring healing to our planet.

SONG OF THE BLOOD LODGE

In ancient times, the women's Bleeding Lodge was a structure set apart from the rest of the community where women would go to dream and communicate with the Ancestors when they were bleeding. Since life follows the cycles of the Earth and the Moon, activities of our Ancient Ancestors also closely followed the cycles of the Earth and Moon. The women all cycled together, ovulating at the full Moon and bleeding at the new Moon.

When women started to bleed, they left their homes and families to go to the sacred introspective space of the Bleeding Lodge. The Lodge was honored and respected by the entire community, for the dreams and visions of the bleeding women brought vital survival information such as planting and healing knowledge and guidance on community relations. When there were questions that needed to be answered, the women would go to the Lodge and ask the Ancestors. All questions were always answered by the Ancient Ancestors. The entire community benefited through the powerful gifts of the women's bleeding cycle.

Since our Ancient Grandmothers probably all bled together, many women shared the Womb Lodge at one time. Ceremonies to honor our womb cycles, celebrate the cycles of the Earth and Moon, and rites of passage were developed by these women from visions and dreams during their bleeding times in the Sacred Lodge. These traditions were

passed down in the initiatory rites of the Blood Lodge from mother to daughter.

As our current culture has separated us so far from honoring the cycles of the Earth and Moon, these ancient women's rites have become almost forgotten. But, as we granddaughters of these ancient women dream during our bleeding cycles, fragments of their powerful honoring and healing ceremonies fill our spirits. We know that there is a wisdom within our wombs that is our birthright.

The spirits of the Ancient Ones have returned to teach us ways of honoring and healing the Earth. It is no coincidence that these Grandmothers are feeding our dreams at this time when the Earth is in dire need of the healing ceremonies of the Blood Lodges. We must return to the old ceremonies of honoring if we want to heal ourselves and our planet. The answers to our survival questions will come through the Blood Lodges.

During our bleeding times, our Grandmothers can help us remember ancient ceremonies, wisdom and rites of passage. We must remember to ask, and they will teach us. The Ancient Ancestors know all the answers and they will help us remember everything we need to know, just as they helped our Ancestors.

Our Blood Lodges today are not usually a particular physical place but more an attitude of community that occurs whenever women come together in any Sacred Space to honor and celebrate our bleeding cycle. So, we make our womb-space wherever we meet . . . a spare room in someone's house, in the basement of a local church or YWCA, or any private outdoor place where women can be safe and uninterrupted.

The Bleeding Lodge is when women come together to celebrate the ancient ceremonies of honoring our bleeding cycles, communicating with the ancestors, sharing our gifts and passing the women's wisdom on to our daughters. The Lodge reminds us that we live within the cycles of the Earth and Moon. When we honor our cycles, we honor the cycles of life. When we honor our wombs,

we honor the Great Mother. Remembering and recreating these ancient ceremonies will bring right relation to all children of Earth. Perhaps, eventually, Bleeding Lodges will once again become respected women's places in our communities.

SONG OF MY WOMB

My womb cycles are the cycles of my life. My womb teaches me of my body and spirit and the connections I have with all of my relations and our Mother, the Earth. My womb is the center of my creativity and the place where my Guardian Spirit speaks. It is here in my womb-space, the core of my being, where I learn and grow.

My womb awakens me in the night when I am ovulating or bleeding. These are the times when she has strong messages for me. She must speak, and I must listen, in order to maintain balance and harmony in my life.

It used to be, I accepted all those degrading attitudes that society teaches us about a woman's body. You know, the "dirtiness" of menstrual blood, and the need for secretness about "that time of the month" that we dare not speak to others about, let alone give any tell-tale signs of bleeding. I strongly felt the pressure to flaunt my woman's body, yet hide my woman's gift. All the feelings of being different and somehow not "good enough" during this time of natural bodily functioning made me dread the coming of my blood each month.

Even my trusted girlfriends reinforced this negative self-image. We couldn't wait until we were old enough to bleed so that we could experience this secret that the older girls talked about in the gym

locker room. But, as soon as we began our cycles, we lived each month dreading this "curse." When we got a little older some of us dreaded not getting this "curse" because that could mean we were pregnant. The inconvenience of our cycles took over all of our lives and all activities were cleverly planned to hide this "problem."

Sensing this special time of passage, I felt elated at finally starting my bloodcycle. But, the lack of support and recognition I received soon lead to feelings of shame. There were no joys in discovering the flowering depths of my woman's body, no rites of passage; only a few whispers and snickers from the few friends I dared tell about this event, and a few hushed words from my mother about how to use and secretly dispose of the sanitary pads. Now things would be different between me and the boys, she told me. And they were. The snide remarks in school, and later on the job about particular women being "on the rag" if they were too independent, moody or outspoken, became all too common. I quickly began to regret growing up because it meant hiding who I was.

Now that I had become a woman, I found my cycles ridiculed, and felt my body unclean, and my spirit pressured to perform each day of the month as if nothing unusual were happening. When I complained about this and demanded womb-time, I was told that this was "all part of becoming a woman" and now it was time for me to "act grown up."

So, cycle after cycle, I recited to my womb these foreign ideals until I finally had myself convinced that I was no different, performed no less and did not require special attention during those days. I must have thought that if I kept it up, my bleeding would go away, or at least stop being such an inconvenience. But underneath it all, my womb, like a needy child demanding attention, got louder and louder until I was forced to spend the better part of my bleeding days in pain and in bed. It wasn't until then that I finally took the opportunity to listen to my cycle.

We live in a society where our roots to the Earth Mother are forgotten and we are not encouraged to honor and celebrate the cycles of

women. Yet, somewhere deep inside my womb, the voices of the Grandmothers spoke and my womb has insisted that I remember their ancient blood celebrations and the power of my special gift of Womb Medicine.

Because we are the daughters of the Earth, women carry within our wombs her rhythm. All of the answers to all of the questions are within our wombs. The cycles of bleeding are indeed the keys to the mysteries of life.

During those bleeding days spent in bed, my Grandmothers came in dreams and shamanic journeys to teach me the old ways of honoring women's bleeding cycles. Each Moon, they brought me a new lesson and a new celebration. Through the teachings of my Grandmothers, I reconnected with the cycles of the Earth and Moon and the wisdom of my womb.

As my knowledge of Womb Medicine began to grow, I brought healing and balance into my life. My womb taught me about the herbs and foods that would nourish her. My Grandmother taught me how to massage my womb and send her energy. I set aside a special place where I could go to celebrate my bleeding. At first, I would try to fit in time when I was bleeding to go there to meditate, but now I eagerly look forward to canceling my plans at the first drop of blood to spend as much healing time in my Sacred Space as possible. I was also given symbols: a blood stone, a bleeding skirt and a shell necklace to use to make this time special and sacred.

Each Moon brought the opportunity to give or make myself a gift. I began to talk about my special time to others and some of my family and friends began to acknowledge it. Everyone really noticed a difference in me.

As I learned to heal my womb and live by her wisdom, my self-image changed. I notice that if I look to my bleeding days with anticipation, I use the intense pre-menstrual energy for positive creation rather than developing "P.M.S. symptoms." I like feeling my womb round as the Moon. I recognize that if I do feel uncom-

fortable, it's my body expressing her special needs. So, I try to allow plenty of space for *me* during this most personal holiday. My cramps, pain, and excessive bleeding have become virtually nonexistent. My inner glow is reflected in my relationships and work every day of the month.

The wisdom of my Grandmothers taught me to honor the Earth Mother, my Ancestors, and all of my sisters and brothers. The Earth gives so much to us . . . She gives us our very life. The Grandmothers have taught me to show my appreciation of Earth by giving back of my life . . . my blood. As our womb-blood brings healing and wisdom to us, so it brings healing to our sick Mother Earth and awakens our understanding of the Wheel of Life. As the Earth heals, her abundance increases and our environment becomes one that supports life. Peace will prevail and respect for the wisdom and power of women's bleeding cycles will return. The medicine of our womb-blood can heal the entire Earth.

The Grandmothers have directed me to share these teachings and ceremonies so that other women will awaken to their own womb-songs and men will awaken to honor women and Mother Earth as creators of life.

Although some of these ceremonies are similar to specific traditions, the wisdom given by my Grandmothers comes from no particular traditional source. The shamanic journeys, dreams and ceremonies that I share here are all part of remembering the wisdom that holds together the Hoop of Life. Perhaps they are only fragments of that wisdom given back to us now to return a spiritual focus in honoring the Earth and healing ourselves. I am honored to share these teachings.

13

BLEEDING CELEBRATION SONG

I am me
I am me
My body cleansed
My power unleashed
My spirit free!

SONG OF THE GRANDMOTHERS

Grandmother, your granddaughter is calling you
Grandmother, your granddaughter is calling you
I call from my spirit
I call from my womb
My womb remembers the journeys of your lives
In my power time, I seek your wisdom
In my blood times, I seek your healing
Grandmother, your granddaughter is calling you
Grandmother, your granddaughter is calling you.

SONG OF THE GRANDMOTHERS

Through our wombs, we are connected to our mothers, their mothers, their mothers before them and all of our Grandmothers all the way back to the first woman, the Ancient Ancestors and the original spirits of life, the Elementals—all the way back to the Earth Mother herself. Through our wombs, we daughters know the story of the evolution of life.

During our bleeding cycles, we are especially open to perceiving this connection. When we begin to bleed each month, we step outside the normal boundaries of physical reality. Transcending the limitations of time and space, we are able to experience the wisdom of the Ancient Ancestors and learn from their teachings. Women are able to feel, through our womb-roots, the Web of Life that connects all the children of Mother Earth.

It is through these roots that the voices of our Grandmothers speak, providing guidance and healing, and allowing us access to the Ancient Sacred Wisdom of the mysteries of life. The Grandmothers have all of the answers to all of our questions, and they have the knowledge to help us survive all the difficult trials of the Trickster.

The Grandmothers are keepers of the sacred baskets. These baskets contain the original wisdom of the mysteries of life, the spirit

16

medicine of the Sacred Web, the knowledge of plant use and of sacred healing energy. The four sacred foods are in the baskets and all of the knowledge of the Medicine Wheel is kept within the care of these Ancient Teachers. During the Bleeding Lodge ceremonies, the Grandmothers give us gifts from the sacred baskets in the form of teachings. The women then take this wisdom out to the community. As women, our birthright is to learn the Grandmothers' teachings through the Bleeding Lodge, so that we can bring this sacred wisdom back to our relationships with all of our sisters and brothers.

In our blood dreams, we can speak directly with our Grandmothers. We know that they are still with us. The bleeding women are the connection that keeps alive the Ancient Wisdom to pass along to our daughters. Because women bleed and create new life, we are the keepers of wisdom of the Ancient Ancestors. All we have to do to receive their guidance is *ask*.

All of us carry within our cells the memories of the lives of our grandparents. In this way, all of our Ancestors are a part of our lives every day. Through this memory link, they give us gifts and talents to use as we walk our paths. Through this link, they speak to us, reminding us where we came from.

Certainly, each particular set of grandparents contributes to how we individually look: our skin, hair and eye colors, features, build, and many other characteristics. Every time we look in the mirror, we are reminded of the gifts given to us by our Ancestors. Do we remember to honor them when we see their smiling faces in the glass in front of us?

Honoring our bleeding wombs is one of the ways that we can honor our Grandmothers. We welcome the bloodflow that opens the doorway between the worlds, so that we can speak with them and listen to their teachings. We burn candles at our Grandmothers' altars and sing the honoring songs to remember their lives. We invite the Grandmothers into the Blood Lodge to celebrate the bleeding ceremony by bringing their pictures and memory boards to our circles. By honoring our bleeding wombs and thanking the Grandmothers for enabling us to live

through the life they have given to our parents and grandparents, we honor the Spiral of Life.

The Grandmothers speak to us in our Lodge and in our spirit journeys. They drift into our blood dreams at night to sing to us. We can hear their voices and their guidance upon the winds, in the running streams and in the songs of the birds. The Grandmothers bring us presents and help create changes in our lives whenever we ask them to. They give whatever is needed to granddaughters who remember them and ask for their gifts. All we need to do is listen to hear their advice. It may come in the most unexpected way at the most unexpected time. And be patient. The Grandmothers always hear us and act at the right time, although that may not always be exactly when we want them to!

Women can take personal, family or community relationships and situations that are in need of healing into the Bleeding Lodge and ask the Grandmothers for wisdom and guidance to bring about fair, healing resolutions. We sing to ask the Grandmothers to help us, we meditate on all the viewpoints surrounding our concern, and we listen through the drum to feel their wisdom in our hearts.

Then, passing around the spirit feather, each woman speaks her piece of the message that is our answer. In that way, the wisdom of all the Grandmothers is heard. Putting all the pieces together gives us a clear perspective on what is needed to solve our problem. Depending on the message each woman has received from her own Grandmother, we will all know the course of action to take to make the necessary changes for the resolution of our problem. The voice of each Grandmother is equally important in the healing ceremonies of the Blood Lodge.

At this time, the Grandmothers are waiting for their granddaughters to remember them and invite them once again into the Blood Lodges. The Ancestors have never left us. They call to us every day. Our Grandmothers are waiting for us to remember where we came from.

When the Grandmothers speak through the bleeding women, they bring the gifts of the sacred baskets to the people. Their messages should never be doubted for they always speak with the best interest of their children and grandchildren. When the people again honor the bleeding women and the voices of the Ancestors, a new harmony will be known for all will once again be in right relation.

SONG OF YOUR GRANDMOTHER'S WISDOM

Have someone read this meditation to a group in the Bleeding Lodge, or else put it on tape so that everyone can connect to their Grandmothers' wisdom together.

Find a comfortable place to sit or lie down. Rest your hands gently on your womb. Allow your body to become fully relaxed all the way out to your edges.

Let your breathing slow to a comfortable rhythm . . . inhaling peacefulness . . . and exhaling tension. Clear your thoughts so that your attention stays fully centered on your womb space. Connect with your womb and let her tell you what part of your cycle you are in right now.

If you are bleeding, feel the power and magic in this special time. If you are not bleeding, remember a time when you felt the flow of your blood and the specialness of your bleeding.

Now feel your blood flowing out of your womb and seeping down into the Earth. As your blood flows, it forms roots that connect you to the Earth Mother. These roots flow all the way down to the womb from where all life comes. Travel down these roots, making your way to the Great Womb . . .

Feel yourself inside a dark, wet tunnel and move with the rhythm of life pulsating there.

As you enter the Womb of the Earth, a circle of Grandmothers await. They are softly singing your womb chant. Can you hear their song?

Bodies of every imaginable size and shape are dancing around you. All of the clans are represented in the circle. As the Grandmothers dance around you, you see smiles of welcome on all of their faces.

Your Ancestors are among them. One of your Grandmothers leaves the circle and comes towards you. You can see her face clearly and you know her name.

As you greet her, she reaches her hand out to touch your womb. When she removes it, there remains with you the print of her blood . . . your connection to her through the Spiral of Life. Her womb blood becomes your womb blood.

She is here to teach you about this blood line that passes through each woman from womb to womb . . . mother to daughter . . . we are all connected through our cycles.

She has wisdom and gifts from the Ancient Ancestors for you. Be open to receive all of her teachings and spend as much time with her as you need to let things become clear.

When your Grandmother is finished, thank her and ask what you can do to honor her.

Follow your Grandmother back to the circle. You both join in the dance of the Grandmothers and this time, you are singing your womb-power chant with them.

The circle becomes the spiral, and then the dance weaves back up through the tunnel of your roots. You are bringing back all of the wisdom and gifts your Grandmother has given to you. As you come close to your body awareness, you know the Grandmothers have gone, but you can still feel their gentle blessings

and hear the rhythm of your womb-song.

Continue back up the roots until you once again become aware of your womb-space.

Know that you can return to the Great Womb, especially when you are bleeding, to hear the wisdom and guidance of your Grandmother.

Return to everyday awareness slowly. Feel yourself strong and replenished with the blessings of the Grandmothers and the wisdom of your blood connections. Come back to your sacred womb-space often and experience the wisdom and guidance there.

GRANDMOTHERS HONORING SONG

Grandmothers, Grandmothers, we have come
Grandmothers, Grandmothers, we have come
Grandmothers, Grandmothers, your granddaughters call
Dancing and sharing our wisdom

Grandmothers, Grandmothers, hear our song
Grandmothers, your granddaughters call to you
We welcome the presence of your spirits strong
We honor the gift of your teachings

Grandmothers show faces in the moonlight
Come into our dreams when the moon is bright
Grandmothers, granddaughters share bonds of wombs' blood
Passing our gifts to future children

Grandmothers, Grandmothers, we remember
Moontimes when women danced together
Grandmothers and mothers and daughters all
In rhythm with the heart beat of Earth Mother

Grandmothers speak visions from ancient times
And the Sacred Web that binds all life
Grandmothers remind women to walk in our truth
To use our gifts and to honor the Moon

Grandmothers, your granddaughters sing to you
We dance in the night when the Moon is full
Grandmothers, Grandmothers, your granddaughters come
In council to share your wisdom

PART TWO

SONGS OF EARTH HONORING

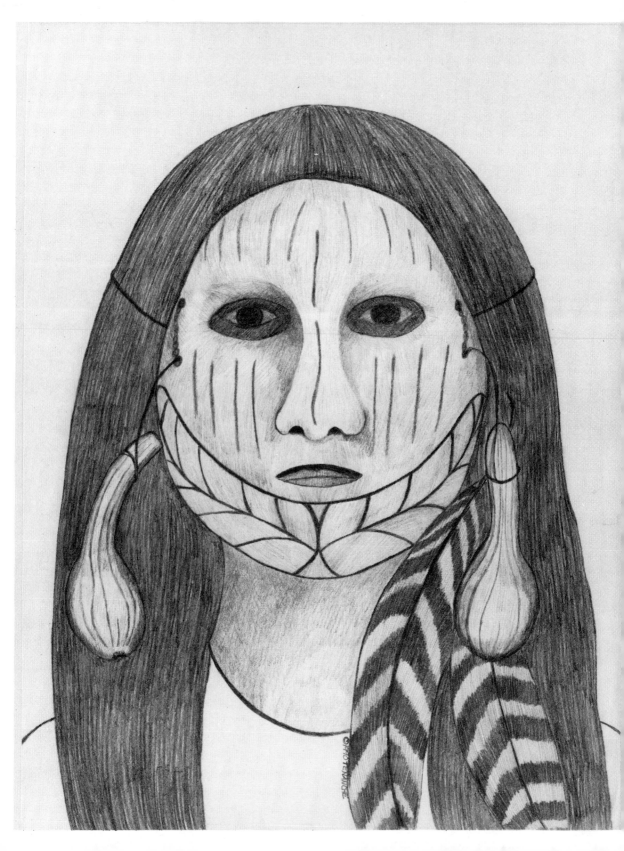

SONG OF THE EARTH

The Earth Mother speaks to me. She is calling me home. I hear her voice in the sounds and songs that come to my ears. I feel her whisper in the winds and sing with the beauty that surrounds me. I smell her sweet and strong scents, urging me on my way. Her essence surrounds me, awakening within my Vibral Core, the center of my being. In my womb-space, deep within the center of my being, I feel the call of the Mother. I know her, for she has always been here.

The Earth Mother calls me when the Moon comes up. Out into the starry darkness I go, following her voice until I come to the place where I have been called.

Sit here on my belly and feel the rhythm of my cycles, she says. The fragrant meadow plants allow me to join them.

Welcome, daughter. It's been so long since you came to hear my stories.

I feel the Earth Mother smiling under me.

Ah, there is no place like home! Sitting among the weeds and flowers, with the stones, mud and a gentle breeze around me, this is my place. As I greet each of these sisters and brothers, I begin to feel my own roots sinking deep down into the Earth. I am a daughter of this Great Earth Mother, a sister to the rocks and trees. I sit tall, letting the healing power of the Moon and stars flow through me. I feel the gifts of

the Mother flowing to me through my roots. This is all I need, for this is who I am.

"Speak to me, Mother," I say, "teach me of your wisdom."

The Moon goes behind the clouds and the creatures of the night hush to hear her voice as she begins the song of creation and renewing life.

I am the Mother of All Things. Way, way back before the structure of time, I was here creating a myriad of life forms. All life in the past has been my doing and all life in the present is also my doing. All potential is within my womb. I exist within you as well as all around you. I am present at all times, in all places, and I will continue on indefinitely into the future. My children will come and go as their lives follow my cycles. Even entire clans and species will come and go but I will always remain.

You know me as the circle: the snake biting her tail. The Ancient Ancestors knew me well and honored my image on pottery and paintings on the walls of the sacred caves. The circle is infinite. The circle represents my gifts of creation and nurturing. The Earth is a circle and so is the womb and the breast. All of these give and honor life.

Having no beginning or end, the circle is eternal. Continuing around and around, cycle after cycle, the circle expands and becomes the spiral. That is the pattern that all life follows.

Look down on your belly and see the symbol of life—your navel. It is here that you as a developing life form, were connected to your physical mother for nourishment before birth. Your navel connects you to your mother and her mother and her mother before her. All the way back into the past, through your Great-Grandmothers, your navel connects you to my Great Womb from where all life comes. Womb to womb, through the navel passes the physical and spiritual lifeline of your species. Your navel is the symbol of your responsibility to honor life, be it your Ancient Ancestors of the past or your great-grandchildren of the future.

The Spiral of Life passes through the navels of the generations as each

one becomes yet a new cycle of growth into the future. Each Moon cycle, each Sun cycle, every new child that is born and every Elder passing back over turns the Spiral on into infinity.

Thus, the spinning of the Web of Life goes on and on.

The Spiral of Life is also the symbol of magic. All things transform as the cycles change. Bringing into being—taking out of being—this is the rhythm of the Universe. If you know my cycles, then you can bring about change and transformation. All of this wisdom is in your womb. You carry within you the rhythm and wisdom of the Universe.

As the Earth Mother speaks, I feel the influence of her cycles and the power of her gifts flowing from her core up through my roots until I can feel her wisdom within my womb.

Your womb has strong and powerful teachings. Each cycle when you bleed, listen to your womb, for it is during your bleeding days that this wisdom and magic is strongest. Never underestimate the power that you have as a woman. All of the answers to all of the questions are within your understanding. Go into your womb-space during your bleeding cycle and listen for the answers to guide you. Whether you choose to grow children in your womb or not, all of your gifts and power can teach you plenty. Because we are connected here my daughter, you can always hear my voice.

Earth Mother pauses briefly in her storytelling. Putting my hands on my womb, I can feel the exact phase of my womb cycle at this very moment. Every day of the month there are teachings and healing here for me, not just when I bleed. Just asking for these gifts can bring them to me.

The Earth Mother continues with her story.

So, I am the Mother of All Things and I give form to all life. My womb is the Sacred Cave down under the sea. The great Ancient Ancestors of all beings first emerged from my Womb Cave a long, very long time ago to dance and live on my breasts, the mountains.

29

My son, your father and brother, was the first to emerge from my Womb Cave. You know him as the bright, glowing, healing Sun that illuminates the day. His blessings enable all my other children to grow strong and healthy, for he gives away of himself unto the plants and seeds that become their nourishment. The Sun is the giver of life and health. His gifts bring abundance and positive growth. The Sun follows my seasonal cycles, however, so he is only plentiful and giving for a while. Then, he must give away his life energies in the harvest, go back into my womb for renewal, and await the season of rebirth. This process continues on, cycle after cycle. This Sun is your father because he gives you life and he is your brother because you are both my children. The gifts of the Sun enable you to survive.

The next to emerge from my Womb Cave was another son, twin to your father-brother. This son is the Trickster, the one who is always testing you. Although some of his lessons cause hardships and suffering it is through these situations that you adapt, become stronger and learn new ways of survival. Behind his rough manner there is wisdom. He brings the lessons to teach you to be the best you can be. The Trickster is sly, often speaking inside of you when you least expect it. He is the son of my wild, destructive side.

After the birth of the twins, my daughter the Moon emerged from my Womb Cave. Into the darkness present when the Sun is resting, she went to shine her lovely, luminous light to mark my cycles. She is your sister, for she guides your womb through its twenty-eight day cycles. She also has a special bond with the sea, for she influences the great waters and the cycles of the sea creatures. It is to honor her that women wear shells during their bleeding cycles and on the full Moons. The Moon gives special dreams to her sisters when they bleed. Her light, the new to full Moon cycles, are a reflection of my greater cycles of creation, change and decay. The Moon brings gifts to feed the spirit, for she knows my mysteries.

There is a pause in the story again. The screeching of an owl breaks the silence around me. I lie down on the soft Earth and snuggle closer to hear the rest of the story.

Yes, I am the gentle life-giving Mother. But I am also the Mother who changes and takes back life at the end of each cycle. The Hurricane and Thunder are my children too. Like the Trickster, they bring lessons but they also bring the cleansing that is necessary for my survival. As I give nourishment to all of my children, they must give nourishment back to me. The larger cycle of existence requires participation by all.

As I give life, I also take it back. It is very important that all of my children honor my cycles and live within the harmony of the Sacred Spiral. The children who dishonor me will arouse the anger of my wild nature. You cannot change or destroy your Mother, the Earth. You can only make me angry at your dishonor until I lose patience and take away the gift of life that I have given to you. I give you everything you need, but I can also turn a harsh face to you if you do not give me back respect.

Members of your species at the present time are creating disharmony within the Sacred Spiral. They have forgotten their relationships with their sisters and brothers. They abuse me, their Mother, and cause me great loss and suffering. I am alive, just like all of you. I am your Mother. Listen to the voice of my wild side warning you to remember your Mother and your family. Remember where you came from and gently remind all of the people to do the same remembering. I am calling all of my children to come home to their roots.

The women will lead the healing of my illness, my dis-harmony, because they know the wisdom and rhythm of the Universe are inside their wombs. Every woman is a teacher, a healer, a wise woman, because every woman can hear my voice in her womb. It is this sacred knowledge that will ensure the survival of your species.

I feel a sadness as she speaks these words. I know that some of the people and organizations that I must deal with through my daily activities deny our relationship to the Earth and other creatures. Sometimes I feel that most places I go the Earth Mother is forgotten. What can one woman do to help awaken these closed minds?

Ah! Give voice to her wisdom, speak of her beauty which I see all

around me. Sing her songs and tell her stories. These I know well; they are gifts to me at my Moon times. I will freely speak them to awaken my sisters and brothers, and to teach the children about where they came from. This is the wisdom that will come through each woman in the Bleeding Lodge and be taken back into our communities to begin the healing process of ourselves and our planet.

I feel the Earth Mother underneath me gently smiling as she continues weaving the story of creation.

So, I am the Mother that gives birth and I am the Mother that takes life back through death. That is the way of my cycles; birth . . . change . . . death . . . rebirth. This process is one of continual transformation.

You, for instance, are always changing. When you were created, growing inside of your mother's womb, a part of the Great Spirit of the Universe was connected to your physical form by the Great Web of Grandmother Spider. Your body goes through a continual process of change as you grow, becoming strong and healthy, and sometimes becoming weak or sick. This is all a part of your natural growth. You need times of rest and introspection as well as times of celebration and work. Your body follows my yearly cycles, wanting to get out in the summer sun to work and play, and then slowing down in winter, requiring rest and space for thinking.

Your spirit, too, grows with new experiences and changes along with your thought and awareness. Your spirit always reflects the Great Mystery and the Universe is always a reflection of the awareness of all beings. What you think affects the entire Web, all of your sisters and brothers, just as clearly as your actions affect them. Best to understand this relationship and keep your thoughts to those you wish to pass on.

As living is a part of my cycle, so is death. Death is the great give-away. As the plants die, they provide food and nourishment for you to live. As the hunter sings the hunting song, animals will give away their lives knowing that their purpose is to feed others. You too will give away at the end of your life. Your body will nurture my body as you become food for

your sisters and brothers. At the end, your spirit will go back to the Great Universal Spirit, the Great Mystery once again to fill the void from where all awareness comes. As your life is a gift, so is your death.

In the Web of Life, every being is connected to and dependent upon each other. Both physical bodies and spirits are forever in a process of growing and changing from one life form to another. As you die, your awareness returns to the Great Mystery, universal awareness, while at the same time, other parts of that Great Spirit are being connected through the Web to newly developing forms of life. The cycle continues to create, change, transform and replenish both form and spirit, as the Spiral continues outward.

You know this universal rhythm, these cycles, in your womb. Following the dance of your sister, the Moon, each month, your womb experiences the birth/death cycle. In this deep level, you know my cycles of creation and trans- formation, for your womb also has the power to create life or take it back. In your cycles, you sometimes dance with my Mother/Nurturer self and create life. In your cycles, you also sometimes dance with my wild self and your womb reflects my likeness as the Wild Mother.

Your womb knows the process of change and transformation of the seed . . . from seed to roots to shoots to flowers and fruit and back to seed again. Your womb knows life and creation. Your womb knows death and the void. Your womb knows change and survival. It is within this process of existence, these cycles of life, that all wisdom comes.

I put my hands to my womb to hear the rhythm and wisdom of the Universe. The Moon comes out from behind the clouds. I can feel her gentle influences on my cycles as my womb follows her twenty-eight day travel from darkness to fullness. Ever constant and steady, this cycle reflects the heartbeat of the Earth. In the fullness of the Moonlight, the meadow plants sway softly and the night creatures sing and dance their dance of survival.

You connect to all of them through your womb, the Mother continues, *you are all sisters and brothers.*

After the birth of the twins, all other life was brought forth from my Great

Womb Cave. The rocks, plants and trees, the fish and water creatures, the insects, reptiles, birds and animals emerged, one species at a time. All of these children were put to the test of survival by the Trickster. Some learned to become strong, to avoid danger, to choose foods to eat and how to build their nests. These creatures prospered and passed their survival skills, their instincts, down to their children. They lived in harmony with my cycles and celebrated the dance of the Great Spiral.

Others of these creatures were not so lucky and did not survive the trials of the Trickster to pass their gifts along to their children. These creatures returned to the Womb Cave and were never again seen on the Earth.

The last to be born from my Womb Cave was one human. Unlike the other creatures, this child was sexless and had a much more fragile physical form. This human went to the meadow of life to make a home and learn survival skills. The Trickster sent great hardships and trials to test the human. The human learned through these experiences what to eat, how to heal, and ways of protection from danger, as well as lessons of strength and wisdom. Having proved these abilities, I knew the children of this creature could grow and survive.

From the navel of this human, a drop of blood fell onto the Earth, and on that spot, a man and a woman sprang up made of this blood and clay. These were the parents of your species. From these two were born the six children who were the original clans. Their descendants have gone out to live in all corners of the Earth.

All humans are related, family, sisters and brothers. Although passage of time and the environment have allowed different physical adaptations, all humans are still children of the same parents. All are the grandchildren of the six original clans.

Likewise, the animals, birds, plants, trees, and rocks are your sisters and brothers—all born out of my sacred Womb Cave. All are my children, all are related. Like the circle with no beginning or end, each of my children is equally blessed with gifts of life and nourishment. There are no better or inferior living creatures. Each has its own unique gifts to share and wis-

dom to teach. My beauty, my circle, is a gift to all of my children. The Great Mystery of the Universe is the awareness of all the gifts of life.

Your womb teaches respect for these relations. It is your womb that knows the vibration of life and harmony between all creatures. The lifeline, through your navel, spiritually connects you not only to your children, but also to all other life. Within your womb you are connected to the Great Web. If you honor and respect your womb, you will never forget where you came from, for you will know all of your family—the children of my Great Womb Cave. If you honor your womb, you will remember your relationship to your Mother, the Earth. Then, you will realize how special you are, my daughters, to be able to pass along these connections to the children of the future.

The dance of your womb is the dance of the Spiral of Life, the twenty-eight day cycle that brings about the reality of your existence. Your womb cycles create the great Spiral of Life. Fullness to rest, life to death, your womb is a mirror of my cycles.

The days that you bleed are most powerful. It is then that the spirits speak. Inside your womb, the door opens between the physical and spirit worlds. There are no distinctions then between time and space. Bleeding women can enter the spirit world or communicate with the Ancestors of the ancient past or our future grandchildren. Likewise, bleeding women can easily communicate with family or friends in another location. Sensing energy and vibration, bleeding women move with the knowledge of other dimensions. When women bleed, they have the opportunity to tap into unlimited wisdom and healing for the people. Ancient wisdom moves on into the future, as the Spiral moves outwards forever creating itself anew.

The wisdom of your womb is the teachings of your Grandmothers, all the women who have lived before you. The gifts of your womb come from your connection to my Great Womb Cave under the sea from where all life comes. Each day, at each new phase of your womb cycle, there are different gifts and lessons here for you. Each bleeding cycle, the door to the spirit world opens and the mysteries become more clear. This is the great medicine of your womb-cycle.

Lying on my back on the soft Earth, I take time to feel the dance of the Spiral inside of my womb and in the rhythm of life all around me. I look up at the fullness of the Moon and she smiles at me, sending down a shower of twinkling Moonbeams. Somehow I know that it is no accident that human women are the only female species of life that have a twenty-eight day bleeding cycle. What an honor to be so specially blessed!

Listen, the Earth Mother says softly, *listen, all my daughters, to my song . . . Listen to the voices of your Grandmothers. Retreat into the dreamtime that comes with your bloods to feel the Spiral dancing. Let your wombs teach you how to heal yourselves, your people, and your planet. Honor this wisdom and allow it to guide your Earthwalk.*

The darkness softens as the first light of dawn creeps into the eastern sky. Rising slowly, I thank the Earth Mother for her teachings and prepare an offering to leave at this special place. The air is fresh, and the crows begin to welcome the Sun. The meadow plants give of themselves freely to me and there are lush greens for munching on as well as flowers for my hair. I feel so full . . . so content. As I walk away, I still hear the voice of the Mother.

Dance the Spiral. Make each day a dance to celebrate my rhythms. Remember the magic in your womb and allow each footstep to guide you on your way. Celebrate each moment, for everywhere you look, you will always find a gift from me.

I find myself skipping and dancing on the path towards my home, going into the South to begin this new day, this new round on the Medicine Wheel.

SONG OF EARTH CONNECTION

Read this simple meditation over several times so that you will be able to follow its sequence. Then, go somewhere out of doors where you can sit comfortably on the Earth and not be distracted while you open your channel to connect with the Mother's healing.

Approach your chosen place with soft steps. Take offerings to give away to the Earth and the spirits that live in this Sacred Space and leave them where you feel appropriate. Let the spirits know why you have come, and thank them for sharing their space with you.
Sit or lie directly on the Earth with the palms of both hands and soles of both feet (take your shoes off if possible) fully connecting with the ground. This establishes your link with the Earth Mother.

Breathe several slow, deep breaths, allowing your body to create its own rhythm. Spend some time checking in with your self in all areas of your body.

What is happening in various places within your body? Keep your awareness in the present and in your own space. Put aside obligations or thoughts of others until later. This is your own healing time. Notice any areas that need attention, but don't judge. Just allow yourself to be.

When you feel ready, bring your awareness to your hands and ask the Earth if you may connect with her. Visualize roots of energy extending from your palms and fingers and gently traveling through the Earth, going all the way down to the Womb of the Mother. Do the same with your feet.

You have now opened a channel of communication with the great Earth Mother. Her Womb is the source from where all life comes and all the wisdom we need to heal and survive. It is an honor to come to this place. Spend as long as you need feeling the power and energy here.

When you are ready, focus awareness on your right hand and foot. This is the side of your body where energy is given away. Allow yourself to give back to the Earth through your right hand and foot anything in your body or spirit that you are ready to give away, perhaps situations that you have already learned your lesson from or relationships that are not in your best interest. You are not giving your garbage to the Earth. Know that whatever you are ready to give away will benefit others needing to learn that lesson in order to grow. The womb of the Mother is the place where these transformations take place for the benefit of all of her children. So, trust that your release is helping not only you, but your relations as well. When you have given away all you need at the present, thank the Mother and gently close off this channel.

Now, focus awareness on your left hand and foot. This is the side of your body that receives energy. Allow yourself to receive the gifts that the Earth Mother has for you at this time. Feel that energy coming up from her Womb through your left hand and foot and filling up all the places in your body where it is needed. When you have taken all you need at present, thank the Mother and gently close off this channel.

Spend a few moments just simply feeling your connection with the Mother. Then, gently take back the roots into both of your hands, stretch them out to the Sun and allow the healing energy of the Sun to enter through your palms, refresh your entire being, and flow into the Earth through the roots of your feet. When you are finished, gently take back the roots into the soles of both your feet.

Before leaving, spend some time honoring the Earth Mother at that place, such as picking up any trash lying about. Thank the spirits. Walk away with soft steps. Take the love of the Mother back into your life and share it with everyone you meet.

SONG OF THE SACRED WORDS

Our women have within them
the rhythm of the Universe
ever constant, ever changing
the twenty-eight day cycle of life

Our women are, each one,
a manifestation of The Great Mother
who, with her twenty-eight day cycles of life and death,
brings about the reality
we know as existence

—Caney Indian Spiritual Circle

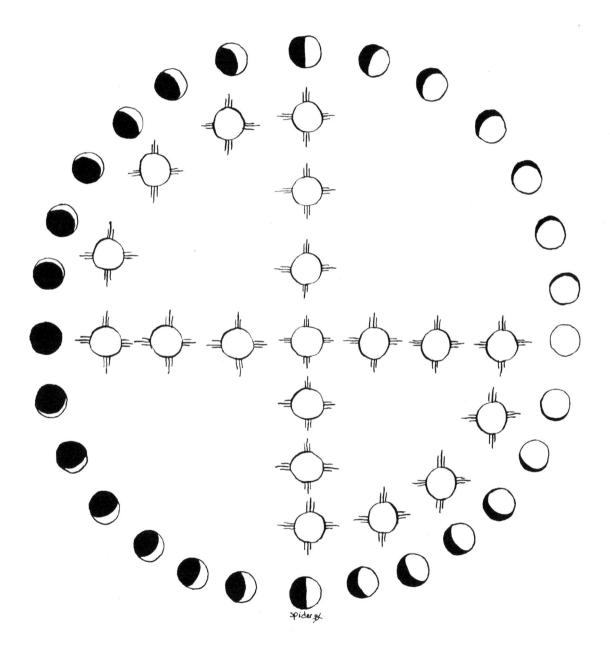

spider gL

SONG OF THE MEDICINE WHEEL

The Medicine Wheel is the circle of life. The round wheel is both the Mother Earth and the womb and breast of our physical mothers. On the circle, all life is related, connected by the Sacred Web. The Wheel is the snake with her tail in her mouth. It is infinite . . . everything that had previously existed, all life at the present, and all potential for the future, the Wheel ever turns, creating at each moment the Spiral of Life.

All of the cycles of life are represented on the Medicine Wheel. The female cycle, represented by the pathway of the twenty-eight day cycle of the Moon, circles clockwise around the outside of the Wheel. The male cycle, represented by the seasonal pathway of the Sun, follows an infinity shaped trail on the inside of the Wheel. Beginning in the South with birth and springtime, the trail goes to the East, place of the Sun and then crosses the center of the Wheel directly over to the West, place of death and spirit. From the West, the trail goes to the North, place of wisdom and renewal, and then courses directly down through the center to the South, where the life cycle begins again. In the ceremonies of the Sun celebration, we dance the pathway of the Sun. In the Bleeding Lodge and Moon ceremonies, we dance the circle/spiral pathway of the Moon.

The pathway around the four directions is another cycle of life represented on the Medicine Wheel. We always begin in the South, the place of birth and rebirth. It is here in the spring that young shoots begin to emerge. The seeds that were previously planted begin to manifest in form. New growth, new life, springs up all around us as the Sun returns from his winter travels.

All potential is here in the South. Each new venture, each new spiral pathway on the Wheel is begun in the place of the South. We keep the wisdom gained through past experiences as we circle with an open mind each round of new lessons. Every time we begin anew in the South, we know that there are an infinite number of possibilities for us and that we are free to choose or change our own path of balance. We also know that we have the abilities to manifest our goals, whatever they may be. We always learn while standing in the direction of the South, the place of the seeker.

The South is the place of children, fun, and playfulness. Like children, we can view the world from the direction of the South with an open mind, free from preconceived beliefs. The South calls us to live in the moment and to greet each person and each situation for what it presents at that moment. By letting go of prejudices and limitations, we can open our minds and free our hearts to perceive anew the flow of life through childlike wonder. Innocence is associated with the South because children look at life as it really is, instead of with preconceived attitudes. When we listen to the child within, we open up to receive the gifts of the South.

It is in the South that we develop an image of ourselves to show the world. And, it is here that we recognize our path, the unique work that we have come into the Earthwalk to contribute. Every time we face the South, we are presented with new variations and possibilities for personal growth. We are like a seedling, another offshoot of the same spirit, yet totally unique in itself. Each time we pass the South, we have the opportunity to plant new seeds and watch them grow. Our image of ourselves and potential for growth is always changing.

Trust and Faith are here, for visualizing our potential. We proceed, knowing that what we need will come when the time is right. When we look at life with childlike wonder and trust, everything is possible.

Green is the color of the South, representing the plants that are our nourishment, the gifts of the Earth. The South is the place of springtime and dawn, and all new beginnings.

The keeper of the gifts of the South is the Green Squash Mother. In our ceremonies, she is represented by a woman who is bleeding and manifests the gifts and blessings of the South by carrying the basket of green squash. One of the three food sisters in the traditions of North America, and a sacred food to the Central American peoples, the sacred squash is the food of innocence and open-mindedness.

This Food Mother dresses in a green flowing robe and wears the squash mask painted as leaves representing the green gifts of the South. The mask has several dried gourds dangling from it, so wearing it brings the fun and spontaneity of the South. There is also a turkey feather on the mask for this bird that walks on the Earth, but does not fly, is the bird of the South. For this reason the blessings of innocence and trust are often given with the turkey feather. The green squash, the sacred food of the South, brings open-mindedness and new beginnings.

As we travel around the Wheel, we come next to the direction of the West. This is the place of the spirit. Once we begin a new round, we must go within to our personal path of truth to integrate this new aspect of self-image. The West is darkness, the silence we find within ourselves when we are all alone. Emotions and intuitions reside here. Feelings in the West sometimes become vague and change shapes from one moment to the next. Although confusion can be found here, this does not mean the West is a place to fear. On

the contrary, looking within ourselves allows us to become better acquainted with our spirit selves and allows us to grow in dimensions beyond the physical.

Black is the color of the West. Stillness, twilight and the transformations of autumn are in the West. Death is also in the West, because in death we relinquish our physical bodies to exist in the dimension of the spirit. Working in the direction of the West, we can transcend physical limitations and barriers of time and space. This is the place of seeing, realizing prophecy, shamanic journeying, and communicating with the Ancestors. Creativity is also in the West for we communicate with the spirits through imagination in song, dance, and painted images.

Each person has a Guardian Spirit (or Spirits) that guides and protects us throughout our lives. This Spirit speaks to us in the West. The more energy we put into developing this relationship, the more clear communications will become. The Guardian Spirit can clarify the answers to any question concerning personal welfare. We need to ask, to receive answers. The Guardian Spirit can be the light in the darkness of the West that reveals the path as we travel around the Wheel.

The keeper of the gifts of the West is the Black Bean Mother. She is also represented in our ceremonies by a woman who is bleeding. She wears a flowing, shadow-like black robe and a dark mask that symbolizes looking into the dark mirror within. Black beans are on the mask and shiny hematite stones that have been used since ancient times to look within. There is also an owl feather on the West mask. The owl is the bird that can see in the darkness and, for this reason, owl feathers are used by shamans to journey through the darkness of the spirit realms.

The West Mother manifests the gifts and blessings of that direction in our ceremonies by carrying the basket of black beans. The sacred food of the West, and another of the three food sisters, black beans, are the mirror that allows us to look within to see our true selves.

Once we have seen with our inner eyes and listened to the guidance of our Guardian Spirits, we move into the North. This is the place of wisdom and healing. The knowledge gained through our experiences in the North depends on our experience in the West and the relationship we have established with our Guardian Spirits.

The North teaches wisdom through everyday experiences. The answers we seek are always within us, and the direction of the North provides us with experiences, so that we can learn and grow from them. Every situation and relationship gives us valuable lessons and gifts. We become wise when we recognize the beauty and wisdom in the world around us. It is always there. All we have to do is simply look for it.

The Trickster Spirit is here in the North, continually facing us with challenges to our self-image, health, resources and relationships. Lessons of the Trickster are often hardships, for situations of necessity and difficulty lead to the inventions of progress and growth. Just when things seem to be going fine, the Trickster brings us a challenge to keep us on our toes. That is because most of us learn better when faced with problems to solve than when we are just taking it easy. If we do not learn from our lesson, we can be assured it will come back to us in a different form over and over again until we find the wisdom meant for us. And, each time, the lesson will become more difficult, pushing us even harder to discover our potential. Best to ask our Guardian Spirit what the lesson of each difficult experience is and attempt to work it out the first time around.

The Trickster never brings lessons too difficult for us to solve. We honor the Trickster Spirit by giving thanks for the gifts that help us survive and grow. After all, if it weren't for the Trickster Spirit, we would be without the technological advances that benefit our everyday lives such as medical, transportation, and communication advancements.

Even though some of the lessons of the North are learned through hardships, it is not necessary to suffer in order to grow. We can return to the West to seek guidance and answers from our Guardian Spirits to find our way out of the maze of the Trickster. When we have learned to see past our limitations in the West, we can even anticipate a lesson before it happens. Thus, our process of growth is accelerated and we can avoid some of the hardships of the learning process. Trusting the advice of our Guardian Spirits can help turn the times of hardship into a powerful growing period.

The North is also the place of the Ancestors. It is here that we can call upon many generations of our grandparents to learn from their experiences. Especially during bleeding cycles, women are open to receive the wisdom of the Grandmothers, all the way back to the first Mother of the Clans. We honor our grandparents for the teachings they give us that enable us to live our lives a little more easily and make the world a better place.

By approaching the direction of the North with an attitude of gratitude, we can receive the gifts of the Ancestors. The wisdom of the ones who have gone before is always available to us here for guidance as we confront our own challenges of the North.

White is the color of this direction, the color of the snows that come from the North. The North is the place of winter and night, the times when our survival skills are challenged. But, white is also the color of healing and is worn by the shaman/healer in ceremony to bring strength, wisdom and healing to the person who is struggling with the trials of the Trickster.

We learn how to heal ourselves in the North, new ways to use plants, new perspectives on listening to our bodies. Solutions to problems are found through the trials of the North. Personal, as well as communal discoveries make our lives easier and more interesting. We become stronger, healthier and more wise after going through our lessons. Peace, abundance and good health are the rewards of our struggles.

The keeper of the North's wisdom and experience is the Cassava Mother. She is also personified in our ceremonies by a woman who is bleeding. The North Mother wears a white cape and white mask with a circle of twenty-eight small crystals around the face to represent the Medicine Wheel. This mask has the red face paint that symbolizes the sacrifice caused by the hardships of the Trickster. There is also a tiny hummingbird feather on the mask. The bird of the North, the hummingbird, disappears during the winter's hardships to return again in the spring, transformed after this season of hardship.

Cassava is the sacred food of the North carried by the North Food Mother in all of our ceremonies. Made from the root of the yuca* plant, cassava is the staple food of Central and South American peoples. Its gifts include nourishment and healing, as well as strength and wisdom. Cassava is made into a type of cracker bread, called cassave, and is used in ceremonies to bring healing and wisdom. Carrying the basket of the sacred food, the Cassava Mother represents the dance that is the process of bringing into being through the work and lessons of our everyday lives.

After we have learned the lessons of the North, we arrive at the place of the East on the Medicine Wheel. This direction is where we gain perspective on our situation and assess the lessons and wisdom gained in relation to the whole. If we have been successful in learning our lessons in the North, our vision in the East will be very clear.

The East is the place of illumination and clear sight. Since the Sun comes up each morning from the East, this direction brings clarity and perspective. It allows us to see what we have learned and integrate this wisdom into our path of truth.

* Yuca (*Manihot utilissima*) is a shrubby plant that grows in Central American tropical climates, not to be confused with the North American Yucca plant. Cassava and Manioc are two common names by which this plant is known. Cassave is the bread that is made from the yuca plant that represents this healing food in our ceremonies.

We see wholeness in the East. Like the hawk rising high above the present situation, we are able to look down from an objective view point and see not only the present but the past, and possible future paths. From this perspective, we can step outside the immediate emotional attachments to any situation and see them in relation to the events prior to its occurrence and the opportunities for future actions. The gift of the East is objectivity, which allows us to see how the fabric of our lives is woven and how the placement of each thread or action affects our over-all pattern.

It is in the East that we can assess our present actions in relation to our life-purpose. This does not necessarily imply judgement. Every lesson, every situation is a gift given to us for our overall growth. There are no coincidences. Everything happens in its own time and just exactly as it is supposed to. More important, everything happens one step at a time. The gifts of the East can help us to see where we are and take future actions, utilizing the wisdom we have gained through our experiences in the North.

The East is the place of understanding relationships, for the objective perspective here lets us see ourselves in relation to the whole Earth and to all of life. This is the place where we can experience the Web of Life, and our connections with all other beings. Again rising like the hawk above the limitations of our egos, we truly understand that we are sisters and brothers with all peoples, as well as the animals, birds, fish, trees, plants and rocks. In the East, we realize that we share the same spirit and that spirit is the very spirit of life that comes with all beings when we emerge from the Womb of the Great Mother.

Here in the East, we see ourselves reflected in the life around us. This is the place on the Medicine Wheel where we can align our intentions with those of the highest and greatest good of our Earth family. What we give and what we do affects the entire fabric of the Web of Life.

We experience illumination in the East, those rare moments of sudden conscious awakening or insights that clarify our existence and purpose in this Earthwalk. In an instant, we suddenly see things within the

perspective of the whole and can clearly understand the truth. Our lives are changed because of these insights, and our relationships deepened with the rest of our Earth family. Thus, the sacred thread becomes visible in a different light with the lessons of each new passing around the Medicine Wheel.

The East is the time of morning and summer when the bright light of the Sun clearly illuminates the world around us. Yellow, like the rays of the Sun, is the color of the East. It is a place of clear vision and understanding. Courage is a gift of the East, for when we see the truth clearly, we are not afraid. The high flying hawk with keen vision and far sight is the bird that brings the gifts of the East to us.

In our ceremonies, the gifts of clear vision are manifested by the Yellow Corn Mother. She is a woman who is bleeding that day and who wears the yellow robe and mask of the East. This mask is shaped like a bird in flight and has two tiny insect wings and a hawk feather on it. The yellow mask also has yellow corn on it, and a large clear quartz crystal above the mind's eye to bring clear sight and understanding through the food mother to our circle.

The basket that she carries is filled with yellow corn. This food is also one of the three sacred food sisters in the traditions of North America, and a sacred plant to South and Central American Peoples, which represents the gifts of nourishment we get from the Sun. The Yellow Corn Mother brings to us an awakening of our connection to the Web of Life.

We never stay long in the direction of illumination. New experiences lead us once more to the South where we travel the Medicine Wheel again. Taking with us the knowledge gained from past lessons, we open up to new growth. Approaching the South this time, we have an attitude of releasing that which is outgrown and no longer needed. Once cleansed, we are ready for a new beginning. Over and over again, our Earthwalk leads us around the path of the

four directions of the Medicine Wheel. Each time we face the directions, we grow closer to our fullest potential.

There are two other paths on the Medicine Wheel. They are also paths travelled in our everyday lives. The Sacred Black Road is the pathway to wisdom and it runs South to North through the Center of the Wheel. We approach the wisdom path from the South, the place of birth and innocence. On this path are the lessons of the physical world through which we learn and grow. The Black Road is a continuum, as we are always looking to the wisdom of the North to teach us.

The Sacred Red Road is the pathway of spiritual awareness and runs West to East through the center of the Wheel. We approach the place of spirit connection from the West. By looking within and becoming acquainted with ourselves and our Guardian Spirits, we can learn to see the truth and understand our relationship with all life. On this path are the spiritual lessons through which we become aware of our place and purpose in everyday activities. The Red Road is also a continuum, for we are always getting to know ourselves better and striving for a glimpse of illumination to make our understanding more clear.

These sacred roads intersect in the center of the Medicine Wheel, the place of balance. In the place of balance, the gifts of all four of the directions are available. We are in harmony with our never-ending travel on the sacred roads, for the place that they intersect is where physical and spiritual growth come together to manifest love, truth and peace.

We are also in the center of the round path of the Moon along the parameter of our circle represented by twenty-eight stones or shells, and that center is located at the intersection of the place where the Sun path crosses itself on its yearly journey between the directions. Peace is manifested where these two paths cross. The place of balance is the truth path. Any person can reach the place of balance by listening to her/his inner stillness. When women first begin each cycle of bleeding, we start

from the center of balance. Our special bleeding gifts can help us gain insights and growth because we reach this centering balance with every Moontime.

Each Moon cycle brings yet another opportunity to travel again around the Medicine Wheel. Every day is an opportunity to learn the lessons of the four directions and grow with their gifts. The Medicine Wheel thus provides a rhythm for our lives as we walk within our sacred truth paths. When we are bleeding, we are in the place of balance and are able to access special teachings from each point on the Wheel. We recognize our travels around the Medicine Wheel and honor each of the four directions for their gifts by representing them in our ceremonies as women who are bleeding. The Food Mothers, wearing their special masks and carrying baskets with the sacred foods, manifest the teachings of the directions and bring us their blessings. Each rite of passage ceremony starts a new cycle of travel around the Wheel. The song of the Food Mothers reminds us that the Wheel is ever turning.

EARTH MOTHER'S SONG

I will raise my voice aloft
in the Mother's song of praise

Sing the beauty of her cycles
in the sacred lunar days

I will raise my voice aloft
in the Mother's song of praise

—Translation of a Caney Indian
Spiritual Circle chant

53

SONG OF THE EARTH'S CYCLES

As the Wheel of the year turns in its never ending cycle, we celebrate the four holidays that represent the faces that the Earth Mother shows to us. Birth, life/abundance, death and gestation/transformation are the faces of the Earth.

These holidays, Spring Equinox, Summer Solstice, Fall Equinox, Winter Solstice, are the seasons of the year. In winter, the Mother gestates new seeds and transforms the decay into food for new growth. Spring brings the birth of green shoots, flowers and animals. Abundance of beauty and harvests of food she gives in the summer. And, in the fall, the Mother takes back life as she prepares to go inward and start the process again.

Each season is both an ending and beginning. Each marks the passage of the Mother in her cycles as she grows and changes. The year, the circle, becomes the foundation for the ever-reaching outward Spiral of Life. We gather on each of these days in the Women's Lodge to honor the Mother as she goes through her cycles. Women are intimately connected to these Earth cycles, the seasons. Our wombs follow a similar process of growth and change as we cycle each month. Our process is becoming fertile at ovulation, giving life (the life-blood is menstrual blood), giving death (emptiness and turning inward to begin a new growth cycle). If we choose to give

birth through becoming pregnant, we then follow a larger cycle that is yet another reflection of the Earth's seasonal cycles of creating life. Whether or not we choose to create children, our wombs still continually reflect the cycles of the Earth Mother. Each woman is then a manifestation of the Great Mother herself.

Since we are so deeply connected to the Earth's seasonal passages through our wombs, we celebrate the holidays in the Bleeding Lodge. We celebrate life. We give thanks for the gifts given freely to us from the Mother. We celebrate change and death. And, we honor the process of transformation through which the Earth replenishes herself.

It is the ceremonies of the women, especially where we offer our life-blood back to the Earth Mother, that will insure the turning of the Wheel, the abundance of the crops, the visions and healings in the winter, the complete passing over of those who have died, and the coming of spring again. These ceremonies of the Women's Lodge are important for the whole community, and the entire planet, to survive. The Grandmothers say, *"The Earth gives to us every day of her gifts, her life. We must give back to her. The process of life is not one way, it is a circle. The sacredness of the gift of life is not complete unless the women offer their life-blood back to the Mother from where all life comes."*

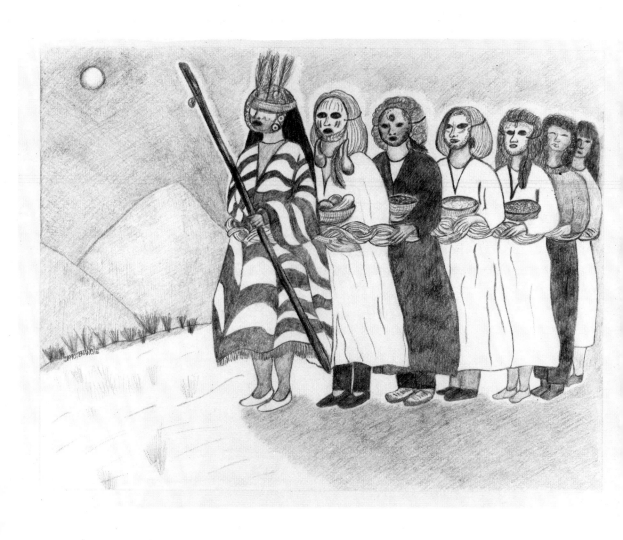

SONG OF THE SPRING EQUINOX

When the cycle begins in the spring, the Food Mothers lead the women out into the fields to perform the planting ceremony, asking the Earth Mother once again to send forth her gifts.

The cold winds of winter have started to recede, and by now days and nights are of equal length. As the snows melt, the ground and trees appear barren. If we look closely, we can begin to make out some progress on the growth of tiny buds that have been sleeping on the branches all winter long. The Sun comes around for longer periods of time, warming the Earth and warming us. Day by day, more birds are coming back. Sun and rain gently coax the Mother awake. It is time to stretch and begin anew.

This is the season of the Green Squash Mother. Spring is the time when the seeds send up their young green shoots to reach out to the returning sunlight. The plants give their gifts freely to all without judgement or preconceptions. With the innocence of the South Mother, the plants grow with the gifts of playfulness, unconditional love and beauty.

The beginning of this new Sun cycle brings potential for growth that has not been previously experienced. With excitement, we walk our paths, delighting in the beauty we meet along the way. We stop to admire the song of an unfolding flower or to play with a young hop-

ping toad in a puddle. In our own lives, we recognize a new cycle of growth also. The Green Squash Mother brings to us the trust to walk in new directions as our paths unfold in places we have never been before. As we begin each round of the Medicine Wheel in the South, we begin each Sun cycle in the spring. Every spring, we walk with the Green Squash Mother in the place of innocence and renewal.

We feel the rhythm of the Universe singing in our wombs. This is a time of high expectations. Having survived the harsh weather and perhaps sickness or other hardships that winter brought, we now look forward to the return of the warm Sun that brings health and harvest. We emerge from our hibernations feeling deep down the stirrings of our own creation inspired by the springtime beauty of all around us.

SNAKE DANCE AND SPRING PLANTING CEREMONY

The music of the conch shell calls the women to the tree circle outside of our Bleeding Lodge. Twenty-eight trees, each a spoke of the female path on the Medicine Wheel, enclose a magical grove. These trees are our teachers, passing along the wisdom of the Ancient Ancestors. The Tree Spirits went deep down into their roots during the winter to seek replenishment inside the Womb of the Earth Mother. They are returning just in time for our ceremony, and each woman stops as she enters the circle to welcome one of them back.

The women are each wearing the feathers or fur of their spirit helpers, for in this ceremony we ask the assistance of our Guardian Spirits in calling out to the Earth Mother. Four Women who are bleeding today are wearing the masks of the Food Mothers and carrying the baskets of sacred food, as well as the special planting staffs. These staffs are painted with red spirals and womb symbols and are embellished with many shells. The shells and symbols speak of women's gift of fertility that reflects the gifts of the Earth Mother during this spring season and the staffs are only used at the spring planting ceremony. Because of our ability to bring new life into the Earthwalk, it is the women who must perform each cycle the sacred planting ceremony asking the Earth Mother to renew her gifts to the community.

An earthen bowl of salt water representing the Womb of the Great

Mother is passed around the circle for each woman to purify her thoughts, her words and her heart. A pregnant woman wears the feathers and robe of the Earth Mother in our circle today, her swollen belly representing this cycle of the Earth Mother about to give birth in the form of the new life returning in the spring. She smudges the four directions, the Earth, and the Sky, and then each woman present. As the swirling smoke of sage and copal surrounds the circle, we enter into Sacred Space.

We paint our faces with our menstrual blood in this ceremony to represent the power that we have to create new life through our monthly bleeding cycle. Those who are not bleeding will paint their faces also, but instead will use a red plant substance. Through painting our faces, we honor ourselves as manifestations of the Great Earth Mother. Thus empowered, we all represent the fertility of the Earth Mother herself in this season of new growth.

If it is warm enough today, the women who are bleeding may be able to sit on the Earth and bleed on her. We welcome this sacred experience of bonding with Mother Earth and being able to return healing and nourishment to her.

The drums beat and speak the songs of the spirits. Our own spirit helpers come to join us in the circle. Each woman softly sings her own spirit song, calling upon the wisdom and guidance of her Guardian Spirit to assist with this dance of calling forth life from the Mother's Womb.

An empty shell and a small knife are passed around the circle. Each woman cuts a tiny piece of her hair into the shell. This represents our give-away and the transformation that occurs when new life is born out of the cave of the Earth Mother's Womb. Our hair is symbolic of the spirit that returns to the Womb Cave after life, only to be reborn again in the next cycle.

While this shell is going around, the earthen bowl of salt water is being passed again. As each woman holds the bowl, she will contemplate the similarity between herself and the Earth Mother.

Looking into the water, she feels the connection of her womb to the great Sea Womb of the Mother. Each woman also sees the past and future cycles reflected in the salt water as her own Grandmothers speak their wisdom today in this ceremony.

When the shell and the bowl return to the Earth Mother, she holds them, one in each hand, out into the circle and says the sacred words. . . . *We women have within us the rhythm of the Universe, ever constant and changing, the twenty-eight day cycle of life. We are each a manifestation of the Great Mother, as our twenty-eight day cycles bring about the reality of our existence.*

The Earth Mother lights the hair and allows all of it to burn into a soft resin. Then, mixing some salt water into the resin with her finger, she makes a thin paste. The Earth Mother paints her face with this paste to represent the transformation of life during this new cycle. She passes the shell around the circle a second time and each woman again paints her face with this paste. Looking around at each of our sisters in the circle, we see ourselves reflecting the new life given birth by the Earth Mother in this season. When each woman has completed her painting and connecting to the Earth Mother, we form a circle inside the twenty-eight trees to begin the dance of the snake.

The Earth Mother has been blindfolded. Seated in the center of the circle, now she is the Mother asleep in winter. Over her head, long cords of rope connected by a large ring are tied to a branch high up in one of the oldest trees. Each woman takes one of the cords, each of us becoming a part of the Women's Medicine Wheel of the twenty-eight day cycle. Standing on the outer edge of the circle, we look like spokes in a giant wheel. The dance begins, turning this Wheel of the year to bring in the springtime.

Our steps cross the center of the wheel, back and forth, in a dance that is the intricate pattern of life renewing itself. Together the women weave the fabric of life . . . bringing into being, releasing, transforming into a new being. Around the Earth Mother woman we dance and sing the celebration of life returning. As we dance, we weave into the snake-

braid our personal goals for the coming season of abundance. The dance becomes a trance, as the power of the Earth Mother becomes stronger with the weaving of the snake.

When the weaving is finished down to the last few inches, the completed snake is taken down from the tree. The ring is tied onto the belt of the Earth Mother woman and the snake wound around her, binding her arms and her womb. The women then prepare for the planting ceremony where the Food Mothers again coax her into giving her gifts.

Following the Food Mothers, the procession dances away from the tree circle to the nearby field where we will do the planting ceremony. The bound and blindfolded woman representing the Earth Mother is led by another woman who guides her steps. The baskets of the Food Mothers are piled high with sacred foods in the hopes of an abundant harvest this season. Loudly drumming, rattling and singing the chant of womb healing, the women dance the Earth Mother awake. By the time we reach the field, small birds are circling overhead. We know that She is listening to our song.

The women form a circle again, with the Food Mothers standing in each of the four directions, and the woman representing the Earth Mother in the center. The drumming and singing continue during the planting ceremony.

First, the Green Food Mother of the South steps forward with her basket of green squash. She asks the blessings of the spirits of the South, as she slowly begins to part the Earth with her planting staff. When she has dug deep enough, the South Mother will plant the sacred squash seeds and ask the Earth Mother to grow the gifts of innocence and open-mindedness for the people. She then offers a gift of tobacco into the Earth and nourishes the seeds with the gift of blood from her womb. The Earth Mother shakes the rain rattle over the Squash Mother as she covers her planting with Earth to ensure that the squash seeds will grow abundantly.

The Black Food Mother of the West steps forward next with her

basket of black beans. She slowly parts the Earth with her planting staff, while asking the blessings of the spirits of the West. When her hole is completed, she plants a small handful of black beans and asks the Earth Mother to grow the gifts of inner-knowing for the people, so that they can maintain their connections to the Guardian Spirits. The West Mother makes an offering of tobacco into the Earth and also nourishes the bean seeds with her womb-blood. Moving into the direction of the West, the Earth Mother shakes the rain rattle over the Black Bean Mother, as she covers her seeds with Earth. The music of the rattle calls the Water Spirits of the sky to send their gifts down to the Earth so that the black bean seeds can grow abundantly this season.

In the North, the White Food Mother steps forward with her basket of cassave, the food of wisdom and healing. She calls out to the spirits of the North for their blessing, as she begins to make a place in the Earth with her planting staff to plant her seeds. When she has completed her digging, the Cassava Mother, will plant the sacred cassave bread or yuca root and she asks the Earth Mother to grow wisdom and health and connections with the Ancestors for all the people. Making her offerings of tobacco and womb-blood, she gently returns the Earth to the place where she has planted her seeds. Over the head of the Cassava Mother, the rain rattle once again calls the Water Spirits to send their nourishment, so that the seeds of the North can grow abundantly.

Last, the Yellow Food Mother of the East steps forward with her basket of sacred corn. She asks the blessings of the Earth Spirits as she makes a planting space in the Earth with her staff. Into her hole she places a small handful of corn and asks the Earth Mother to grow the gifts of inspiration and clarity for the people. She also offers gifts of tobacco and womb-blood to the Earth before covering over her seeds. The rain rattle calls out one last time, asking the Rain Spirits to nourish the seeds of the East into abundant growth for all of the people.

The Food Mothers each ask for a plentiful harvest and thank the Earth Mother for the gifts she has given to us to bring us through the winter's hardships. Each woman in the circle then has the opportunity

SNAKE
DANCE
AND
SPRING
PLANTING
CEREMONY

to take a few seeds from the Food Mothers' baskets, particularly seeds of the direction each is currently working in, as we personally go around the Medicine Wheel. As the women plant their seeds around the outer edge of the circle, we plant one seed for each goal that we want to grow in this new season. We each ask the Earth Mother and our Spirit Guides to bring healing and abundance into our lives in whatever way we need these gifts. The rain rattles are passed around the circle and they call the Rain Spirits to nourish our goals into reality with their water of transformation.

We thank the Earth Mother for accepting our seeds, and offer her our own healing energy so that she too will grow healthy and be replenished in this new season. The winds carry the message of our song out to the spirits and the Mother responds with a big yawn, ruffling our hair and the feathers we are wearing. We know that she is awake now.

The music of the drums continues, as the women sing the song of celebration. Once again we have awakened the Mother to a new cycle, and we are sure that she will provide us with abundance. The Food Mothers and other women of the circle form a line behind the Earth Mother, one hand on the shoulder of the woman in front of her to form the snake. The Food Mothers are holding their baskets of sacred foods and the other women are holding rattles in their free hands. The blindfolded Earth Mother is guided by the Elder Grandmother, and the other women, out of the planting circle and out of the circle of trees. In a snake-like dance, the women go back to a place in the community where the men and boy children wait to join in the celebration. As the women, return, they bring to the people the promise of renewal with the awakening of the Earth Mother.

When the snake reaches the community place, it is time to un-bind the woman who represents the Earth Mother to symbolically show the people that the Mother is awake and the seeds of new life are growing inside her womb. Her blindfold is removed and the

Earth Mother once again looks upon the faces of her children after her long sleep. One of the men, who represents the Sun Spirit, cuts the cords that bind the woven snake to the belt of the Earth Mother woman.

As she is unwound, the women take hold of the snake and become the spirit of the Earth Mother. The pregnant Earth Mother woman leads the other women in the dance of the snake, with slithering grace around the circle of men and children. When the Mother Snake returns to dance in the springtime, the people know that the plants will soon return. There is much joy and song as she weaves her way back to the community to dance around our fires.

Only the women can perform this sacred planting ceremony to ask the Earth Mother to bring abundant growth. Once the women sing their song to the Mother, the entire community can feel her renewal becoming stronger every day on the spring winds. The singing, dancing and joyful celebration of life returning will continue into the night.

Tomorrow, everyone will share in the work of preparing what is needed so that our gardens can be planted during the next full Moon cycle. The rains will come soon, as they always respond to the call of our rattles. As each single seed is planted, we all sing the songs of honoring the Earth Mother and thanking her for her gifts. She always gives us plenty.

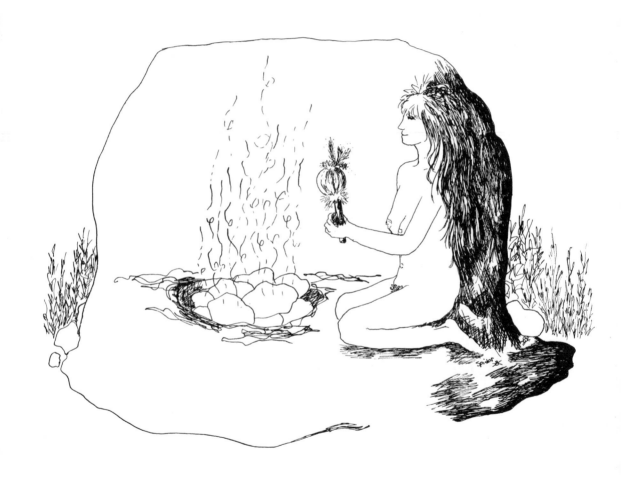

SONG OF THE SUMMER SOLSTICE

As the days lengthen and the Sun grows warmer, we meet again in the Bleeding Lodge to celebrate the season of fullness.

Seeds that have been planted in our gardens in the springtime become plants that grow larger every day. It will not be long before their flowers develop into tiny fruits and vegetables. Some of the early flowers and herbs have already reached maturity and we take walks in the beauty of the sunshine to collect them for salads and brews. The early harvest whets our appetites for what's to come.

Leaves have fully opened on the trees and flowers are everywhere. Each week, a new plant bursts into blossom, changing the colors of the meadows and forest floors. The Earth smells fresh with the scents of growing ferns, flowers, and warm summer rains. Bees, butterflies, insects and animals perform their special dances and sing their own songs of life. Everywhere we look, the Earth is unfolding her beauty.

The Yellow Corn Mother dances in this cycle of fullness of the Sun. At the height of its path, the Sun gives us warmth, abundance, and life through nourishing our plant-foods. As the Sun illuminates our long days, we honor our relations in the family of Earth children and know that we all share the same life spirit, just as we share the light of the Sun.

The light of the long summer days brings us the gifts of clarity from the Yellow Corn Mother. We take time off to lie back and reflect on our

lives and our work. The Sun lights up the Eastern sky so that we can see clearly. We take the time to focus on the gifts of the Yellow Corn Mother so that we can put our own lives into perspective. We become inspired by the world around us. The gift of clear vision allows us to walk our paths with purpose. The Yellow Corn Mother gives us strength and courage to carry out our work. In this season of fullness, we know that we have all we need to survive and grow.

This is the season to spend out of doors close to the Mother. The return of the Sun brings health and harmony and increases our energy. We feel awake ... we feel our relationship with the rest of the Web of Life ... we radiate well-being. This is a time of activity and sharing. We travel to visit other clans to sit in council, to share teachings, and trade wares.

Looking around us, we observe all creatures busy with their activities of creating, nurturing and celebrating life. We too gather to join in the celebration of the Dance of Life.

WOMEN'S SUMMER SOLSTICE CEREMONY
AND PURIFICATION LODGE CEREMONY

While the men are away performing their dance to honor the Sun Spirit, the women meet in the tree circle outside the Bleeding Lodge. Most of us have been here all day or for several days, sleeping out under the stars and preparing the Sacred Space for the solstice ceremony. Plants inside the tree circle have been carefully attended to and an altar has been made of woven reeds and laid in the center. Bright red, black and white batiked banners painted with the sacred bleeding symbols have been hung from the tree branches that enclose our womb space. The twenty-eight wise old trees lend their music to our circle, as we celebrate our twenty-eight day bleeding cycle of fullness. Like the Mother, we give freely of our nourishing gifts of life in this season.

A few women have been sitting by the roots of the Sacred Trees all day, listening to the voices of the Ancient Tree Spirits that have now awakened after their winter's slumber. The spirits of the trees that had gone down into their roots to seek replenishment in the winter have now returned as the new leaves. These wise women will later share with us the messages of the trees and the wisdom they bring from the Earth Mother's Womb.

Other women have spent the day gathering wood and stones for the purification fire. A special Lodge has been ceremonially constructed in a small meadow nearby. Earlier today, the women have made offerings

to the Tree Spirits and gathered the saplings that form the structure of the Lodge. All day, they have tended the fire that will heat the rocks for the special ceremony tonight to purify our bodies and minds and awaken our spirits to the voice of the Mother.

The conch shell calls, signalling everyone that the ceremony is about to begin. All but the fire keepers head toward the tree circle. The fire keepers have the honor of staying to feed the fire and sing to the stones as they heat up in preparation for the purification ceremony. Even our young daughters who have been playing in the meadow come running to join in the dance.

A woman who has recently given birth will represent the Earth Mother today. She slings her small child to her breast as she dons the shells and feathers that signify her as the embodiment as the Mother of Fullness. This woman is the manifestation of the Earth Mother in summer who is giving life through the nourishment of the plants.

Taking the shell with sage and copal, she goes around the circle with a hawk feather sending swirls of purifying smoke around each woman. The earthenware bowl of salt water is passed around the circle. purifying thoughts, words, and hearts before the ceremony begins.

This holiday honors the Sun and the life that comes as nourishment to us from the Earth. Four women who are bleeding are representing this bounty in our circle by wearing the masks of the Food Mothers and carrying their baskets piled high with the sacred foods. Each Food Mother stands in the direction that gives the gifts of her sacred food as we form the circle to begin the dance.

Singing to honor our Mother Earth, we begin the steps of a round dance. Inside the grove of trees, we circle around, arm in arm. Old familiar faces as well as friendly smiling visitors sing together in harmony. We are the circle.... We are the snake with her tail in her mouth... We are the fullness of the Earth Mother. We recognize that the strong spirit of women is reflected in the Earth's changing cycles. In our sacred circle, we sing to the life unfolding around us,

as we dance the Wheel into a new season.

When the dance is finished, we stop, out of breath, to reconnect with the Earth. The woman representing the Earth Mother turns to the woman on her left and gives her a blessing of fullness and abundance. She picks up from the altar a bowl of soft mud and she dips her fingers into it and paints the woman's face with this gift of the Mother. The Earth Mother goes around the circle, giving each woman a blessing while painting our faces. As she paints, the circle is silent. We contemplate our personal gifts and give thanks for the generosity of our Mother, the Earth.

The Food Mothers go around the circle next, each giving a blessing and offering a taste of food from their baskets. We eat of the green squash, sacred food of innocence and trust . . . the black beans, sacred food of inner knowing . . . the white cassave bread, sacred food of wisdom . . . the yellow corn, sacred food of illumination and inspiration. As we eat of the sacred foods, we are nourished by the gifts of the four directions.

The remainder of this ceremony is for the teaching and sharing of women's wisdom and Earth lore, for summer is the season for learning and growing like the plants around us. The youngest in our circle is the first to hold the talking stick and speak her words of wisdom. Regardless of age, each of us has a special sacred wisdom obtained through the lessons we have experienced and the guidance of our Spirit Guides. We respect and honor each woman for what she chooses to share with us, so that our own wisdom may grow.

Healing, plant use, tree wisdom, divination are shared with our visitors from other clans, and they, in turn, share their work with us. Creation stories and tales of our Grandmothers and the spirits are spun here in our sacred Womb Lodge so that each woman remembers who she is and where she came from. The talking stick eventually is held by every woman in the circle. Long after the girls have returned to their games in the meadow, the women sit sharing, dreaming and remembering magic.

When dark approaches, the fire keepers signal that the Purification Lodge ceremony is ready to begin. The women who wish to attend the ceremony, leave the circle and walk down towards the meadow. Not all of the women choose to participate in this intense introspective part of the Summer Solstice festivities. Some will stay inside the tree circle to be spirit watchers, singing and dancing with the Nature Spirits. Other women will begin a fire to prepare food for the feast that will follow. The young girls return to the tree circle and stretch out their blankets under the stars to dream in the sweetness of the Mother's Womb.

The first stars appear in the sky, as the women in the meadow undress and prepare to enter the Lodge. In the flickering firelight, the sacredness of the small womblike hut is visible. The saplings that we have used to build the hut and then covered with blankets have created a Sacred Space. The shape of the Lodge represents the Womb of the Earth Mother and the ceremony inside is one of transformation and rebirth.

Earlier, the women had gone into the woods to sing to the Tree Spirits and ask for saplings to give away so that the structure of the Lodge could be built. Oak, beech, willow and maple spirits all become the Lodge and a part of the prayer of our ceremony. Heavy canvas tarps and thick wool blankets cover the saplings, making the Lodge a totally dark, womblike space. In the center of the Lodge, a shallow pit has been dug and lined with flat pebbles. It is here that the hot rocks will sing their song for our purification. The Earth that has been removed from this pit is placed in a small mound outside the entrance to the Lodge and personal sacred objects can be left there to be blessed by the energy of the ceremony.

We line up to enter this place of regeneration and transformation. Stepping through the door of the East, we honor our Grandmothers. We enter the womb-space to begin anew our path

around the Medicine Wheel. This ceremony is a cleansing of our physical bodies, a release of emotions that need letting go, and an opening up of our connection to the spirits. Our songs and prayers inside the Lodge will make changes in many dimensions of our lives. We always emerge with a new perspective, reborn in spirit.

Together, we sit in a close circle on the soft Earth inside the hut. Steaming red rocks are brought inside and carefully placed in the pit. Their heat warms the already hot summer's evening. When all the rocks for the first round are brought inside, the fire keepers close the doorflap. All that is visible in the Lodge is glowing sparks from sacred herbs sprinkled on the rocks. Their aroma relaxes our awareness and encourages our bodies to perspire.

Big ladles of water are poured over the rocks. Steam rises and penetrates the very core of our beings. We chant to the Mother, asking for cleansing and healing. In this place of spirit, we can sense the rhythm of the Universe unfolding.

The Food Mother of the South speaks of releasing and gently coaxes us to put aside everyday awareness to let the child inside play. Like seeds sending down shoots into the Womb of the Mother, we watch ourselves grow and blossom. Those of us who are bleeding tonight let our womb blood flow freely back to the Mother and feel a particularly strong, magical connection.

We see ourselves as we truly are, and we see the simplicity of the Dance of Life. Shedding our worldly faces, we let go of prejudice and limitations, becoming the shining light of universal awareness. All that we need is right here. In this round of purification, we relax and play, trusting our place in the Web of Life.

Four rounds are in this ceremony. The doorway opens and more glowing stones, fresh from the fire, are brought into the pit. When the doorflap is closed, water is once again poured onto the rocks. Herb water that has been steeping all day in the Sun is also poured on the rocks and releases in the steam to open our senses. These are the dreaming herbs of the West and their gifts help us communicate with the

73

spirits. This second round of purification will allow us to speak with our Spirit Guides.

The West Food Mother begins a chant of simple breathing. In this round of inner knowing, there are no words. We speak to the spirits with the sound of our breath and they speak back to us through our breath sounds and in our hearts. Each woman's chant is uniquely her own, and all the breath chants blend together in a harmonious chorus.

Drums and rattles sing out, as awareness turns within. This is a powerful experience for each woman. Some receive messages from Spirit Guides or from the Ancient Ancestors, and everyone experiences a deep, nonverbal understanding of herself. This breath chant calls out intensely with the voices of the spirits, and then fades into deep silence, so we can listen. We stay for a long time in this Spirit Place, for there is no importance of time passage in this Lodge.

Once again, the fire keepers open the doorflap and bring in red, glowing rocks from the purification fire. We sit in silence, watching the rocks glow and listening to the songs of the stone people. When the door is closed, we go around the circle and each woman takes a moment to honor one of her grandmothers and the wisdom she has learned from her. The round of the North is where we connect to our Ancestors' wisdom.

Chanting begins again, as the water is dipped onto the rocks. Hot steam rises as our bodies continue their process of cleansing. We sing for healing and guidance.

The Food Mother of the North speaks of the lessons of the Trickster Spirit. Although harsh and difficult, wisdom and health have been brought to us through these experiences. We contemplate our own lessons and give thanks to the spirits for teaching us. We feel strength and power gained through facing the hardships of the North... and health and cleansing of our bodies through harsh steam and sweating inside the Lodge. We feel the magic of transformation here, inside the Mother's Womb. Chanting to honor our

Grandmothers, we come to know their gifts of wisdom. They give us all we need to know.

After awhile, the doorflap opens again and more red hot rocks are brought into the Lodge for the final round of ceremony. The sweet smell of copal rises as powdered resin is sprinkled on the glowing stones. This is the round of connecting to the Web.

We have reached the final place of the Medicine Wheel in the East. This time, as water is poured onto the rocks, we feel refreshed and revitalized. Speaking of the Web that connects all beings, the East Food Mother begins to connect all the women in the circle. As we join hands to wombs, we become the East Spirit, the circle of life. We form a womb circle, the reflection of the fullness of the Womb of the Earth Mother in the summer.

From our womb circle here in the purification Lodge, we send out the Web to include family, friends and all our relations everywhere. We spin healing and blessings though our Web and back to the Earth, as we sing of the Earth's cycles and our womb cycles. We thank the trees that have formed our Lodge, the stones that sang with us, the water that purified us and the spirits that taught us here tonight.

When the doorflap opens for the last time, we silently leave the Lodge, again honoring our Grandmothers. Each woman is reborn in many ways. Our spirits glow as we hit the cooler night air. By this time, the Moon is high up in the sky and the stars shine brightly. Lying flat on the Earth, we ground our ceremony by feeling Her fullness against our flesh.

As most of the women have fasted today, we are eager to begin the feast. Smells from the cooking fires call us back up to the Lodge to a luscious dinner. Sometime later, the men will return from their dance and we will continue with a communal celebration. Throughout the rest of the long, warm days of this season, we celebrate each moment of the fullness of the Mother and know that she has blessed us.

SONG OF THE FALL EQUINOX

In the autumn, the spirits of the Grandmothers teach us of the death cycle. Summer's abundance is waning as the daylight becomes shorter each day, and the energy of the Sun goes into the grain providing our food, our life-blood for the winter. This, the third holiday to honor the cycles of the Earth Mother, reminds us that we will all return to her Great Womb.

Nights are becoming longer and there is a definite chill in the evening air. Perhaps we have spent the day harvesting the vegetables from our gardens or foraging for wild herbs to be dried or tinctured. Following the dance of our animal sisters and brothers, we collect and are busy storing food for the coming winter season. In the Bleeding Lodge, the Grandmothers teach us the skills of harvesting food and medicines. We share this knowledge and teach the community about the gifts that our Grandmothers have given to us.

This is the season of the Black Bean Mother. As the Sun's cycle shortens, it draws us into a period of introspection. The time is now to focus inward and connect with our Guardian Spirits. After the traveling, sharing and learning of the summer, we integrate our lessons. We allow ourselves times of stillness to hear our own heartbeat and the heartbeat of the Earth Mother. The voices of our Guardian Spirits remind us of who we are and why we are here.

The Black Bean Mother allows us to face our own mortality in this season. As we share in the harvesting of the food, we are reminded that we too shall some day become the give-away. The voices of the Ancestors sing to us from the trees during the fall evenings, telling us of the Spirit Place where they have gone. The gifts of the Black Bean Mother allow us to go inside to confront our fears about our own death. Through the Black Bean Mother's gift of introspection, we learn who we are and we connect to the wisdom of our Guardian Spirits and the Ancient Ancestors. We know that even in the darkness we have support and guidance.

We stop to give thanks often in this season. The long, warm days of summer have provided us with food and health, lazy times to sit on the Earth and swim in her waters, and yet another cycle of personal growth. We had asked for these gifts at the spring planting ceremony and today we will show our gratitude to the spirits and Earth Mother for providing for our needs. Each day of the fall season brings us yet another opportunity to be grateful for the many gifts around us.

The women meet in a space separate from the rest of the community for this ceremony, because it is they who must dance the snake dance to symbolically weave the Web of Life onto the next cycle. As the Earth Mother gives life, the Wild Mother takes life back. This dance is to honor her part in the cycle, the give-away at the end of the season.

SNAKE DANCE AND THANKSGIVING CEREMONY

The conch shell calls the women into the grove of twenty-eight sacred trees. Some of the leaves have already fallen and lie among the sacred objects on our altar. The smell of fall is in the cool air, and the women wear bright red shawls and shell necklaces. A woman from the Lodge of the Grandmothers who is no longer bleeding will wear the feathers, shells, and robe of the Earth Mother. She represents the manifestation of the Mother in this cycle of harvest. Four other women from the Elder's Lodge, one sitting in each of the four directions on the Medicine Wheel, will wear the masks of the Food Mothers. Today their baskets will be piled high with the bounty from our gardens. The conch shell calls four times to alert the spirits that our ceremony is about to begin.

This time of year, the Ancestor Spirits are close to our physical world. We can feel their presence in the trees as we take late afternoon walks. We honor our Grandmothers in this ceremony and ask them to join in our dance. The Earth Mother woman carries the staff of the Grandmothers tonight and represents the wisdom of these Ancient Ancestors in our presence.

The earthenware bowl of salt water is passed around the circle for purification and meditation. The salt water reminds us of the origins of life in the great Womb Cave in the sea. The salt water teaches us of the power of the blood of our wombs. As we meditate, the Grandmother Spirits surround our circle. Each of them also carries an earthenware bowl. Women in the circle begin to sing the womb chant. As the song

becomes strong and our connections with the Ancestors open, the Grandmothers raise their bowls in blessing and pour them over the heads of the women in the circle. They give us their wisdom. Each woman hears the voice of her Grandmother and becomes wiser.

Fall is the time to sacrifice. As the winter approaches, hardships will come to test our personal and community survival skills. Cold weather weakens our immune systems which causes us to get sick. Our gardens stop producing food. We must maintain shelter from the storms of winter and prepare for lack of mobility due to bad weather. Darkness descends more quickly each day, as the Sun goes away.

In this ceremony, we recognize the sacrifice of giving away, for it is the give-away that enables us to reap abundant harvests. The Sun gives away life energy into the food plants and herbs so that we may have nourishment. We give away that which we no longer need to make room for future growth. The Spiral turns once again. Women who are bleeding today have painted their faces with their womb-blood to symbolize the gifts of life that the Earth Mother gives us in the harvest, and the gifts of healing and wisdom that we bring to the community through our bleeding times. An empty shell and a knife are passed around the circle and each woman cuts off a small piece of her hair to symbolize the sacrifice of this cycle of change. These sacrifices are burned in the fires of transformation. Their resinous ashes are mixed with salt water to make a paste by the Earth Mother woman.

When the shell is passed around a second time, each woman paints her face with the ashes. Each of us then becomes the image of the Wild Mother, she who brings about changes and takes back life. When the cycle is complete, it is she who takes us to the other side, the Place of Spirit. We honor the gifts that the Wild Mother brings for our growth and the growth of our clan. As we look around at each other, we honor in our mothers, sisters, daughters and grandmothers the power of the Wild Mother.

Bleeding women sacrifice the blood of our wombs every Moon cycle unless we choose to give life to a new child. Menstrual blood is our most precious medicine gift. It connects us to the wisdom of the Ancient Ancestors and brings us the knowledge and healing needed to survive life's hardships and trials. Each Moon brings an opportunity for renewal. As the Moon cycles, our womb cycles, and the Spiral of Life turns, renewing itself endlessly.

When women bleed, we know the essence of the Wild Mother within our wombs. Even the Grandmothers who have stopped bleeding still feel the powerful cycles of the Mother within them. Women experience the completion of the cycle with a very personal understanding. Our bleeding is our harvest time. For all of these gifts, we give thanks.

The women who are of bleeding age have all brought some of their menstrual blood to this special ceremony. Now is the time for the bleeding women to connect to the Earth Mother to thank her for the gifts that she has given to the community during this season of abundance.

The drums of the Grandmothers call their spirit songs out as, one by one, the bleeding women leave the circle to find a special place to honor the Mother. It is essential for the survival of the entire community that we return our gift of womb-blood back to the Earth Mother. This is a primal women's ritual of appreciation, and it is also necessary for the healing and nourishment of the Earth. When we give away our menstrual blood in this sacred way, we are honoring the Wild Mother. Each woman enacts this part of the ceremony in her own personal way.

We are the cycles changing . . . we are the Mother giving birth . . . we are the Mother giving death. Our wombs turn the Spiral of Life.

Just as we did in the spring ceremony, the women dance the snake dance. The woman representing the Earth Mother is blindfolded and sits in the center of our grove of trees. Now she is the Mother going to sleep. The bleeding women return to the circle and each takes a rope hanging from the branches overhead. The drums continue their song, as our footsteps weave the many strands that spin the Web of Life. This

time, each woman weaves into her dance the things she is thankful for in her life. This season, we weave the threads of another cycle complete by giving thanks for yet another harvest.

Chanting and dancing the Spiral of Life, the women make the snake. When the weaving is completed, the snake is tied onto the sash of the blindfolded Earth Mother and wrapped around her, binding her arms and her womb. The four Food Mothers and the other women form a line behind her, one hand on the shoulder of the woman in front of her, the other holding a rattle. The Food Mothers each carry their baskets of sacred food. Guided by the Elder Grandmother, the Earth Mother woman leaves the tree circle and takes us to the bonfire. The Grandmothers follow, guiding our footsteps with the music of the drums.

The women form a circle around the warm fire and we continue singing the chant of our womb cycles. In each of the four directions, the Food Mothers stand with their baskets, ready to perform the give-away part of the ceremony.

First, the Food Mother of the South, the Green Squash Mother, takes her basket of squash near the fire and makes a small give-away of this sacred food into the fire. She thanks the spirits of the South for giving the people the gifts of new beginnings that have come with the past season of growth. She thanks the South Spirits for giving the people their gifts of open-mindedness and trust. The Green Squash Mother gives thanks for the children who have joined our clan this season, and the good relations of the people. When she returns to the snake, she ties onto the braided rope a turkey feather to represent the gifts of the South.

The Black Bean Mother of the West next approaches the fire with her basket of sacred food. She gives away a small handful of black beans into the fire and thanks the spirits of the West for the dreams and guidance they have given the people this past season. The West Mother acknowledges those people in the clan who have completed their vision quests this summer and the young girls who have begun

to bleed and are now a part of the Women's Lodge. She thanks the Guardian Spirits for bringing strength and insights to the people of our clan. When she returns to the snake, she ties an owl feather representing the gifts of the West onto the woven cord.

Stepping near the fire next, the Food Mother of the North carries her basket of cassave bread. She breaks off a small piece of the bread and makes a give-away into the fire of the sacred food of the North. The Cassava Mother thanks the spirits of the North for the wisdom and teachings that the people have been given through their experiences of the past season. She acknowledges and honors the Trickster Spirit, as through his lessons the people grow strong and wise. The North Mother also honors the Ancestor Spirits, especially the Grandmothers, who never stop sharing their wisdom with our clan through the Women's Lodge. As she returns to the snake, the Cassava Mother ties onto the woven cord a tiny hummingbird feather representing the gifts of the North.

Approaching the fire last is the Yellow Corn Mother of the East with her basketful of sacred food. Her give-away into the fire is a small handful of corn. The Yellow Corn Mother thanks the spirits of the East for the gift of clear vision that has been given to the people this season, so that they could live in harmony with all of our sisters and brothers on the Earth. She thanks the East Spirits for the inspiration that has been given to the people to create new and beautiful things, and the courage to go forth without fear. Returning to the snake, the East Mother ties a hawk feather onto the woven braid to represent the gifts of the East.

After the Food Mothers have completed their give aways, the other women in the circle can choose to offer small pieces of copal or sage or gifts of plants from their own gardens. As each woman tosses her give-away into the fire, she thanks her Guardian Spirits, her Grandmothers and the spirits of the four directions for the gifts that they have brought into her life this past season. The women yell out to the spirits and shake their rattles vigorously as the fire burns brightly with their gifts.

As we give thanks, we also recognize the sacrifices of this season.

The give-aways will allow us to survive in the coming season of hardships. We are happy in our celebration, trusting that the spirits will continue to bless us and our families.

The Earth Mother is guided away from the fire, leading the women to the place where the men and children await to join the celebration. When we reach the men's circle, a man who represents the Sun Spirit will cut loose the cord binding the Earth Mother. Her blindfold is removed and the woven snake uncoiled, so that all of the women can hold onto it. Together they dance the slithering dance of the Snake Mother, led by the woman who represents the Earth Mother. Their dance is a celebration of the gifts that the Mother has provided for the clan this season.

Because the Wild Mother has been honored by the women, the seasons change. The wisdom of the women's rite is shared with the men, as they join in our dance of the changing cycles. All of the Ancestors are honored through the songs we sing while we dance. Thanks are given to the Food Mothers and the spirits of the four directions by all of the people in the celebration as our ceremony draws to an end.

The ceremony is followed by feasting and celebration. All of the people share in dishes of baked squash, stewed black beans, cassave bread and steamed corn as well as the bounty from our gardens. Gratitude is expressed to family and friends and the gift blanket is piled high with give-aways to show our appreciation to special people there. The celebration lasts on into the night, and the little ones are fast asleep in their blankets before their Elders start to leave.

Once we return home, each of us will privately honor our grandparents by the altar boards hanging on our walls. The next few days find us preparing our shelters for the coming season and preparing space to dream the winter's dreams of wisdom.

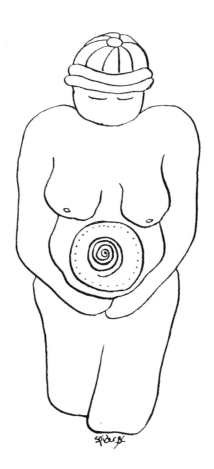

SONG OF THE WINTER SOLSTICE

As the Sun appears less and less each day and the winds blow cold from the North, we each retreat into our personal Sacred Spaces to dream and vision the gifts of winter time.

Outside, the Trickster Spirit is teaching the lessons of survival. Storms and harsh winter weather bring challenges to our shelters, our mobility, and even our health. Few plants are still growing, most of them have been already harvested or mulched. The Tree Spirits have retreated into their roots, traveling down into the womb of the Earth Mother for replenishment. Their green leaves are all gone. Likewise, many of our animal sisters and brothers have migrated to milder climates or settled into their nests for the sleep of hibernation. While the Trickster is teaching us his lessons, the Mother herself has quieted in her cycle during this season of rest.

This is our time for learning and healing. After a summer of traveling and sharing, and the fall that brought busy work preparing for winter, we settle into the quiet of winter to integrate our experiences. Traditionally, work has slowed down in the colder months, as we humans turn inwards to listen to the voice of wisdom.

This is the season of the Cassava Mother, the keeper of the wisdom of the North. She brings knowledge that is gained through

our experiences, so in this season of rest we integrate the lessons that we have learned. Our attention turns from the social gatherings and sharing circles to activities of our own, reading, meditating and baking bread. There is much time on short, snowy days to sit by the fire and think.

Since the Trickster brings challenges to our health, we also learn of healing during the winter. Through the hardships of the colder months, we learn of the needs of our bodies. The gifts of our harvests that we have prepared in summer and fall are most welcome now to bring strength to keep us balanced. By listening to our inner voices, we learn what to use for our healing.

In the winter, the tiny hummingbird disappears only to be seen again in the spring. This bird of the North represents the transformation that is brought about in this time of darkness. Hummingbird medicine follows the Sun's cycle as it shortens and then as it begins to appear a little longer each day in the sky. Our spirits are reflected by the hummingbird who retreats each winter to become healed and transformed and to reappear wiser in the spring, as we once again go around the Medicine Wheel of the year.

When we walk the winter with the guidance of the Cassava Mother, we approach our hardships as lessons and learn from them.

CEREMONY OF VISIONING

While the men meet for the ceremonial winter dance of the Sun, the women prepare for the long night of dreaming.

The women come together in the Bleeding Lodge to celebrate the longest night of the year. We walk in silence to honor this dream time. We come wrapped in brightly colored blankets to shield ourselves from the cold and the lessons of the Trickster. Each woman offers a silent greeting as she approaches the circle, lights her red candle from the large candle in the center, and takes her place on the Medicine Wheel inside the twenty-eight shells. Each woman sits in the direction of the path that she is presently walking on with the lessons in her life. By becoming a part of the Medicine Wheel in this way in this ceremony, insights and wisdom are gained for personal healing.

The woman who represents the Earth Mother this season is a woman who is bleeding today. Winter is the time when our attention turns within and our wombs can prepare to create our dreams just as the Earth is now preparing for the seeds to sprout in the spring. The bleeding Earth Mother represents the manifestation of the ability of women to create through our bleeding cycles as the Mother creates new life. She is the Mother asleep and nurturing the

seeds of renewal. In the season of darkness, she brings a focus for change.

Four other women who are bleeding today sit in the four directions wearing the masks of the Food Mothers and carrying the baskets of sacred food. They bring the blessings of the directions into our dreams.

When all of our sisters have arrived, the Earth Mother smudges the circle, the Food Mothers and all of the women with a large spirit feather. The sweet smell of sage and copal drifts on the air, purifying and renewing our spirits. An earthenware bowl filled with salt water is passed around the circle. Each woman purifies her thoughts, words and heart as she enters the place of stillness. The drums beat the rhythm of the Mother's heartbeat and we settle into her dreams.

We sit in contemplation, listening to the drums and the slow breathing of the Earth Mother outside the Lodge. Through the windows we can see her asleep under a thick, white blanket of snow. Her dreams lead us to the place of inner stillness where we perceive universal peace. Wrapped in our own warm blankets and sitting by the solstice fire, we slumber in the winter rhythm of the Mother's cycle. To each of us she gives gifts of self-awareness and inner wisdom.

The bowl of salt water is passed around the circle again, this time for meditation. The shell is a reminder that we all came from the Womb of the Earth Mother in the sea. Our wombs are each a reflection of the Womb of the Great Mother. Within our wombs are the abilities to create peace and healing, strength and beauty. We have the power to create reality by focusing our thoughts and to create the future through our children within the rhythm of our womb cycles. We have the power to change the world.

Looking into the water deep inside the shell, we can see a tiny crystal and four seeds. The seeds are the sacred foods . . . Squash, black beans, cassave and corn . . . the gifts given to us by each of the four directions on the Medicine Wheel through the Food Mothers. The crystal is the spirit, the awareness of the Great Web that connects all of life in the tapestry of existence.

As the shell goes around, each woman looks within herself to contemplate her own gifts and connections with the Web of Life. Before passing the shell along, each woman speaks her dream, her words of that which she is working towards manifesting for all of us that walk the Earthwalk.

Putting ideas into words brings clarity and is the first step towards making them real. As we share with our sisters, mothers and daughters, we remember that we already have inside our wombs the answers and wisdom to manifest these dreams. We actualize our gift as women to create the future.

In this time of inner listening and inner knowing, we are aware that the seeds of new beginning are once again stirring within the Mother's Womb. Life that will appear in the spring is conceived as a beautiful thought right now in the darkness of winter. Putting the palms of our hands to our wombs, we conceive these beautiful thoughts for positive growth and healing for ourselves, our clans and all our relations on the Great Web.

Starting with the Green Squash Mother in the South, the Food Mothers go around the circle blessing each woman and reminding us of the gifts that come into our lives each day from the spirits of the four directions. *"Mother Squash, with living breath, blesses you with the gifts of renewal. . . Mother Black Bean, with living breath, blesses you with the gifts of spirit dreams. . . Mother Cassava, with living breath, blesses you with wisdom. . . Mother Corn, with living breath, blesses you with clarity and purpose. . ."*

As each of the Food Mothers stands in front of us, we feel the powerful guidance that comes from these spirits as we travel around the Medicine Wheel. We know that we have everything we need in their blessings. We are honored to be standing in our places on the Wheel.

A single rattle begins to sing. Then, drums softly begin to beat. The music they bring awakens us. Out of our silence, soft chanting begins. We sing the sounds of the spirits, the harmony of the Web,

the sleep-song of the Mother. Some of the women shed their blankets and rise to their feet, letting the song speak through their bodies. Celebration and gratitude for the return of life are with us. As we dance, we know the Wheel is turning on, into the new cycle.

A warm glow fills the circle as the singing softens. The woman representing the Earth Mother takes the talking stick. Now in this season of wisdom, it is the time to honor our Grandmothers. As each of us holds the talking stick, we say the name of one of our Grandmothers and thank her for what she has taught us. Some of the women tell short stories about their Grandmothers sharing very special memories of their teachings. Others simply acknowledge their Grandmother for passing along her wisdom and her contributions to the Women's Lodge. Through these shared stories, we are all able to learn through the experiences of all of our Grandmothers, and become wiser. In this season of lessons, we know that the wisdom is here to guide us.

When all the women have spoken, the talking stick is laid to rest and it is time to open the circle. The Food Mothers acknowledge with gratitude each of the four directions for their special lessons and gifts. Each of the women silently makes a wish to send out into the Great Web to all of our sisters and brothers as she blows out her red candle. On this special night of dreamtime, the wishes are particularly magical. Our blessings are felt by all of our relations and then come back to inspire each of the women in the circle. We will take our red candles from the Bleeding Lodge with us to light our personal bleeding ceremonies during the dark nights of winter.

Each of the women has brought gifts to give to the others and they have been lying on the gift blanket during our ceremony. We honor each other on this special night. We share our harvests, poems, drawings and other beautiful creations. The gifts that we have made for our sisters carry our spirit and blessings.

A feast has been prepared with warm winter foods, red berries, and steaming breads. The scent of herbs drifts into the air as the soup is heated, drawing the women away from the twenty-eight shell circle and

into the kitchen. We fill ourselves with the warmth of the food and the love of our sister-friends.

Drinking mugs filled with spiced cider, we sit after eating, chatting and stringing popcorn and berries as solstice gifts for the furry and feathered ones who are still awake outside the Lodge this night.

The women talk on into the night, until the sound of drumming outside signals that the men have returned from their dance.

Wrapping our blankets around us, we leave the Women's Lodge to go dance around the fire with the men. Our dance symbolizes the renewal of the Sun, now growing inside the Womb of the Mother. As the Sun will return a little longer each day now, we have hope for the rebirth of life in the spring. The dance also symbolizes the struggle with the lessons of the Trickster and the triumph of life over darkness. This dance is a celebration of promise for ourselves, our clan and the world.

When the community celebration draws to an end, each of us retreats silently back into the night. Each of the women returns to her own Sacred Space to finish the winter sleep of wisdom and work at creating her own dreams.

SONG OF THE CIRCLE

The circle is forever,
A symbol of all that ever was, all that is now
And all that will become.
The circle is the symbol of the Mother,
The swollen womb belly that brings new life,
The breast that nourishes our wants.

The circle is the symbol of love,
Forever growing and sharing of all spirits,
All is equal in this round.
Changing and spiraling outward in the
Mother's cycles.
The circle, like the candle in the dark,
Is the bright Spirit of Life.

SONG OF BLOOD DREAMS

Entering the Place of the Spirit, I find myself riding in a canoe down a wide flowing stream. On the banks to either side, trees overhang, their lacy, leafy branches touching the water. As the images around me slowly become clearer, I notice fleeting movements among the vegetation on the shore. Although I cannot see the spirits, I feel their presence all around me. Colors vibrate with life, and the sweet songs of birds fill the air. There is a wonderful magical quality to this place, and I feel an ancient wisdom here.

My Spirit Guide is in the canoe with me and together we continue paddling the boat downstream. I feel welcome in this place, and wonder what teaching is here for me.

Looking into the depths of the water, I see the shadow of the Hawk Spirit from the East soaring high above. The hawk brings clear perspective, strength and courage. The East is the place of reaching out to embrace the dream and make it a reality. In my canoe, I follow the direction of the hawk's flight and I paddle right into her dream.

A short while downstream, the hawk flies away from the stream and into the thick trees in the West. I notice a small sandy beach there and prepare to go ashore. Leaving the canoe, I walk into the place of inner vision in the West. At the edge of the beach is a path

94

leading into the forest. I am drawn into the trees with a special sense of expectation.

Not far into the forest is a small hut sitting right off my path. At first glance it almost appears a part of the vegetation. The hut is constructed of tree trunks over which wide leaves and reeds are situated as if to create a womb-like enclosure to shut out the outside. I recognize it at once, a temple to the Great Mother for honoring women's blood times.

I remove my clothes in preparation for entering the hut and notice that I have just begun to bleed. How elated I feel to be sharing my womb blood with the spirits of this special place!

Looking down at my feet, I realize that I am standing in the center of a large symbol drawn in the sand.

"*This symbol will bring your bloods if it is near their time. . .*" More an awareness than a voice explains the strength of this women's medicine. Starting where I am, I slowly begin to walk the spiral path that leads right to the door of the temple.

It is dark inside and, in the momentary blindness, my feet begin to see on their own. Walking softly, sensing the pulse of the Mother with each step, they start to sway in a rhythm that becomes my bleeding celebration dance. Stepping the path of the Spiral, my entire body expresses the cosmic rhythm . . . the cycles of life . . . the cycles of my womb. I am dancing up onto a mound and when I reach the center my dance stops, and I sit gently down on the soft Earth.

My breath has become one with the pulse of the Mother. Here in this healing place I dream the vision of my blood time:

Out of the shadows emerges a Wise Woman with beautiful shining energy. Although I can sense her presence, I am unable to see her clearly with my eyes. She is carrying a large necklace with many round, white shells on it. As she puts it over my head, I feel the heaviness of the shells that reach all the way down to my womb.

The woman also has a small clay pot filled with red blood-paint. She dips a finger into the pot and then slowly begins to trace a symbol of awakening awareness on my forehead. As she paints, I begin to understand and perceive in a different way. The woman continues, painting the Medicine Wheel on my face. Then, she paints my breasts and womb with ancient symbols of women's bleeding medicine. My body awakens to the sacredness of my bleeding time through the magic of the symbols.

She says to me, "You have within you the rhythm of the Universe and you are a manifestation of the Great Mother, for your cycles, like hers, bring about the gifts of life. Always give the Earth Mother a gift of your blood during each bleeding cycle to complete the cycle of life she has given to you. This is a time when the wisdom of the Ancient Ancestors is available to you. Whatever you need for healing or knowledge, ask it during your blood time and it shall be made known to you. Give thanks by giving your blood, your healing gift, back to replenish the Mother."

In this place of deep magic, I become one with the Earth Mother underneath me. We are connected by my blood roots. As I flow into her, I feel the dance of the spirits of the trees outside the hut, speaking their wisdom. I hear the gentle guiding voices of my Spirit Guardians bringing me awareness for the special needs of this cycle of my life. I take all this with me, as I finally go back to my canoe on the beach and back down the stream to my every day reality where I can use the insights to heal my hurts and create my way along this Earthwalk.

PART THREE

SONGS OF CELEBRATION

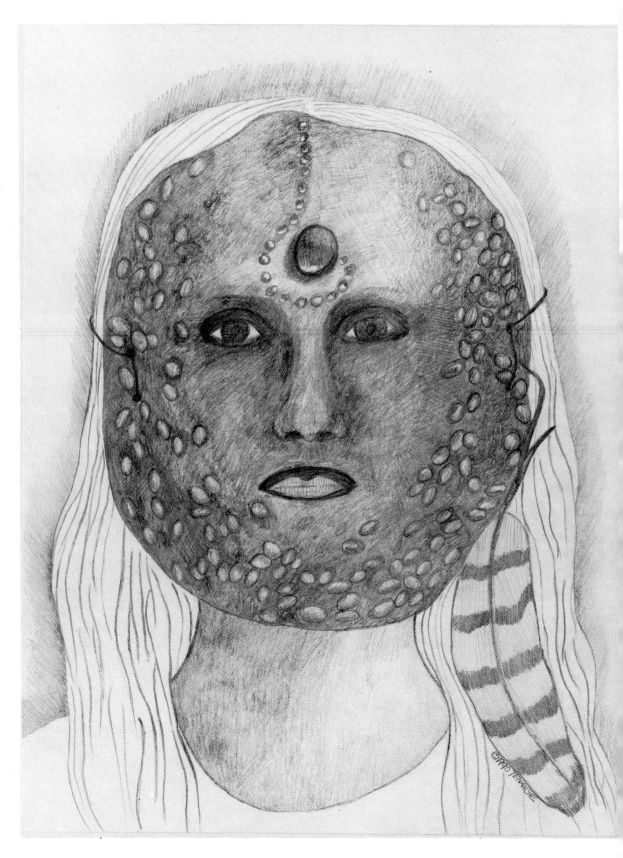

BLEEDING DANCE SONG

Woman Spirit I am . . .
Dreaming deep, I live my roots
of healing and connection with the Mother . . .
Fill me with balance and wisdom . . .
I walk my path in harmony with joy and celebration . . .
I see myself as a reflection of her
my Mother, the Mother of All . . .
my life is a dance in the breeze . . .
I aim carefully and shoot my arrows
bringing me health
and blessings to nurture body and soul . . .
I dance of strength, celebration, appreciation
touching the Earth and letting her strength
draw up through me . . .
taking off to let my spirit soar
in the air
and back again in the great Spiral of Life.

SONG OF CELEBRATION

As the Moon darkens, the women begin preparation for the ceremony to celebrate our bleeding cycle. Whether we are bleeding or not, we all come together at the new Moon to honor our Grandmothers and celebrate this time when our wombs flow in harmony with the Moon.

Since ages long past, women have gathered to celebrate their menstrual bleeding on the new Moon. Before the invention of artificial lighting and unnatural schedules, women all bled together during the new Moon. The Moon has a very powerful influence on the cycles of our wombs just as she has on the tides of the oceans. This influence creates the rhythms that are women's bleeding cycles.

In a natural state of being, unaffected by outer influences, our wombs respond to the Moon's light in an approximate twenty-eight day cycle that reflects the changes made by the lunar orb. Ovulation occurs at the Moon's fullness. This is a time of releasing, planting, community celebrations (such as full Moon ceremonies) and healing others. Bloodflow comes with the dark Moon, bringing a time of personal seclusion, inner work and dreaming. When the Moon is able to speak to our wombs uninterrupted by distractions, then women's cycles will closely follow those of the Moon.

At the present time, given an environment full of toxins and stress, many women have long, short, or irregular bleeding cycles. Not all of us bleed when the Moon darkens into new. Each woman has her own inner cycle however, and setting aside time to celebrate and honor our bloods whenever they occur is more important than celebrating any specific phase of the Moon. Women who live together notice that they begin to follow similar bleeding cycles. We can celebrate the bleeding ceremony alone or with others. In the Women's Lodge, we continue to meet on the new Moon to follow the ancient practice of honoring our bleeding cycles during this phase of her darkness.

Although other female mammals have bleeding cycles, human women alone have cycles that approximate the Moon's twenty-eight day path. She is our sister, for we cycle together. Both the Moon and the women, through our shared twenty-eight day cycles, are manifestations of the Great Earth Mother. The Moon influences the tides of the sea (the womb of the Earth Mother), as well as our wombs. The recognition of these connections makes the bleeding celebration the most sacred of our women's ceremonies.

WOMEN'S BLEEDING CEREMONY

The women who are bleeding today wear special red clothes to the Lodge. During her bleeding meditations, each woman makes with care the clothes that she wears only to bleed in. These clothes reflect her unique bleeding medicine symbols and are lavishly adorned with shells to honor our sister the Moon.

As each woman arrives, she contributes her own objects towards making the Lodge. Red scarves and beautiful bloody bleeding cloths are draped around the circle of twenty-eight shells to form our Womb Lodge. Photographs of our Grandmothers, shells, stones, feathers, flowers, red candles, and musical instruments begin to fill up the altar cloth. As the Lodge is built, it becomes a place of healing and women's wisdom.

When all the women are present, one of the women who is bleeding today will volunteer to wear the special robe, shell necklace and feathered headdress that will make her the symbolic representation of the Earth Mother in our circle. This woman will also wear the smock that has the sacred red bleeding symbols painted on it and she will carry the staff of the Grandmothers.

It is quite an honor to carry the Grandmothers' staff, as it displays the symbols that speak of the life-energy of women's blood and the passages of women's lives. This woman who represents the

Earth Mother will call the Grandmothers to our circle and ask them to share their wisdom. She represents the presence of the Ancestors as well as the Great Mother, as she brings all of their blessings to us. Since each woman is always a manifestation of the Great Mother, we will all eventually have the opportunity to wear the ceremonial shells and lead the dancing.

Four other women who are bleeding this day will dress in the masks and robes of the Food Mothers. They will bring the blessings of the four directions of the Medicine Wheel into our circle. Carrying baskets piled high with the sacred foods, these women also symbolize the nourishment given to us by the Earth Mother.

We are also honored to have present this day several young girls who have not yet passed into their bleeding cycles, and a few Elder women who have passed out of their blood cycles and into the Grandmothers' Lodge. All women are welcome at our bleeding celebrations.

A bowl of salt water is passed around the circle for purification and to remind us of the connection between our womb-blood and the salt water of the sea. A basket of shell necklaces follows, and each woman takes one or several to wear. Wearing shells is one way that we honor the Moon for bringing our blood, our life cycles. We are the sisters of the Moon . . . sisters with the sea children . . . daughters of the Earth.

The dance is about to begin. The woman who represents the Earth Mother signals the spirits by blowing the conch shell out to each of the four directions, the Earth and the Sky. The women follow her back out of the circle and form a line, starting in the direction of the South. We always enter the Medicine Wheel from the South and at each bleeding cycle, we start again in the South, the place of learning and open-mindedness.

As the Moon chant begins, the women start the slow, rocking steps of the Moon cycle dance. The Earth Mother leads the snake-like line of women around the twenty-eight shells and the Womb Lodge in a Spiral of Life-energy renewing itself. The clockwise spiral with a tail is both

our symbol for magic and the symbol of the ability of our wombs to create new life. As we dance, each woman contemplates her own creative ability to manifest what she needs during this womb cycle.

Because the drums call the spirits, the women dance to deeper levels. Becoming a circle, our spiral is now the snake with her tail in her mouth. This is the symbol of the Earth Mother. We are the Earth Mother, for our cycles bring the renewal of her gifts of life. There is no beginning or end to the circle. All life is related, a part of the Mother. As the drumbeat quickens, we are filled with the awareness of the Earth Mother and her cycles. All the women are in right relation, stepping softly on the Earth, with wild cries, we release our healing intentions for the blessing of the Mother.

One by one, the women sink silently back down to feel our roots extending from our wombs and going deep down into the Earth. The sweet smell of burning sage and copal drift on the winds of the four directions. Thoughts become still, as we prepare to honor the Earth Mother.

In the ceremonies where we celebrate a give-away or honor a sacrifice, we paint our faces red. The women in the Bleeding Lodge use menstrual blood to celebrate this phase of our cycle. We wear our blood as an outward sign of the honor brought by our time of power and the wisdom brought by our connection with the Ancestors. We paint the sign of the Medicine Wheel, for our bleeding cycles have a special place on the Wheel. Our blood time is the place of balance in the center of the Wheel where the gifts and wisdom of the four directions come together. As each woman paints her face, she recognizes the connection between her monthly cycle and the universal rhythm of life.

The women and young girls who are not now bleeding will paint their faces with a red plant substance to honor the cycles that all women share at some time during their lives. As the women look around the circle to see each other painted, we recognize our specialness. We see our mothers, sisters, daughters and grandmothers all as

the Great Mother. We know ourselves to be a source of wisdom, having all we need to create our own lives as well as to bring new life into the world.

Women who are bleeding have a responsibility to nourish the Earth with their blood. Sitting in the circle on the soft Earth, the women let their womb blood flow freely back to the Mother. We visualize roots going way down into the Great Womb and give her healing and blessings, as well as our blood, to thank her for the gift of our lives. Somewhere, our intentions manifest as the creation of a new flower bud or some rejuvenation of a polluted stream or the renewal of life for a sick creature. Later, if we return to this circle, we will find the Earth fertile and happy in the places where we have given our menstrual blood. This give-away brings healing to all our relations.

When all of the bleeding women have completed their give-aways, the red and white candles are lit. The white candle represents the light of the Moon that will soon return to the night sky and the red candle represents the bleeding cycle of our wombs, introspective like the Moon at this dark time.

The woman who is the Earth Mother slowly says the sacred words "...I have within me the rhythm of the Universe—ever constant, ever changing, the twenty-eight day cycle of life. I am a manifestation of the Great Mother and, through my cycles of life and death, bring about the reality of existence."

A chant begins in the circle, with all of the women rattling or drumming along as we sing the sacred words "...The women have within them the rhythm of the Universe..." The shell is blown again to call the spirits of the Grandmothers here. The sacred pipe is filled with tobacco, purified with burning sage and then smoked to honor the four directions, the Earth Mother and our Grandmothers. As the pipe goes around the circle, each woman honors her connection with her own Grandmothers and sends it out to the spirits on the sacred tobacco smoke. It is through the smoke of the pipe that each woman can ask for the wisdom of her Grandmothers to answer specific needs, such as advice, or to bring healing. During this part of the ceremony, all

thoughts and actions are direct communications with the spirits, all blessings of respect and honor for the Earth and all of our relations. We smoke with gratitude.

The drumming continues, calling our attention inward. The woman representing the Earth Mother calls the Grandmothers into our circle and each woman has the opportunity to receive the wisdom of one of her own ancestors. Speaking through the drum, our Grandmothers come to bless us and bring us healing. They sang and danced with us in our spiral earlier, and now they speak the wisdom of our womb-times. For each woman the message is different, and for each of us the Grandmothers give a special gift to bring back to our everyday lives.

We connect to our Grandmothers through our wombs. It is from the womb of our mother that we were born, and she from her mother, and she from her mother . . . all the way back to the first woman who was the mother of the clans. Thus, both the rhythm and wisdom of the Universe is here in our wombs.

The answers to all questions can be found within our sacred womb-space and our bleeding days are the times of clarity to receive this information. From the Bleeding Lodges comes the knowledge of plant use, healing, family and community relations as well as personal guidance.

From the Bleeding Lodges will come the wisdom needed to heal the Earth Mother herself and create powerful transformations for all her children. The Grandmothers speak through our wombs that which we need to know to create balance in our lives during this Moon cycle.

Bringing awareness and our Grandmothers' wisdom back to the circle, we begin a chant of womb power. *"I am a woman, a woman, a woman, I am a woman, a strong woman . . . we are the women, the wise ones, the healers, we are the mothers, the strong women. . . ."*

The Earth Mother makes her way around the circle, blessing each woman's womb with the energy of life. *"Blessings my daughter,*

your cycles are the rhythm of the Universe and I give you all you need to survive and grow. . ."

The Food Mothers follow her, giving each woman the blessings of the directions.

"Mother Squash, with living breath, brings you the blessing of innocence."

"Mother Bean, with living breath, gives you the blessing of inner knowing."

"Mother Cassava, with living breath, blesses you with wisdom and healing."

"Mother Corn, with living breath, blesses you with illumination and inspiration."

The spirits have visited our Moon Lodge, spoken their wisdom, and given us their blessings. Joining hands around the circle, we again dance the dance of the Moon cycle, and this time sing songs of honoring and thanksgiving.

The ceremony over, the women settle back in their places in the Womb Lodge to begin the sharing and teaching of women's wisdom. Here is the rhythm and wisdom of the Universe revealed through our wombs and passed from mother to daughter. As each woman takes the talking stick, she speaks of her own bleeding experiences. Healing and growth, pain, as well as laughter, fill the Lodge. We share our innermost pleasures and personal bleeding rituals. We heal each other of the scars of wounds inflicted on our bodies and spirits. Releasing and healing, we cry and become strong together. There are always enough hugs to go around.

The teachings of the Grandmothers are also spoken in the sharing circle. Their voices come to guide us at this crucial time and the Bleeding Lodge is where their gifts to us are put into words. Often, a woman will connect in the Bleeding Lodge with an Ancestor she never knew during life, only to find a deep spiritual bond in the Lodge with that Grandmother.

Ties between mothers and daughters are renewed in the Womb

Lodge. The Women chain, all the way back to the first woman, is open through our bleeding wombs. Each woman through her personal link in this chain, comes to understand the mystery of life and the wisdom of the ages.

Answers to personal decisions, ways to help others or heal ourselves, all are shared in the circle. Every woman shares what she knows, and all women receive whatever they need. *"In the sacred circle, life unfolding goes round and round."*

After each has had a turn to share her wisdom with the talking stick, we draw back into our personal womb-spaces. Placing the palms of our hands on our wombs, we sing the chant of womb blessing. We renew ourselves and fill up our spirits with all of the bountiful gifts given during this ceremony.

Sometimes, the women bring gifts to share with the other women or to leave in the Lodge. These are usually left on a special gift blanket to be blessed during the ceremony and given out as the circle draws to a close. We honor our sisters by sharing our bounty with them through this give-away.

The conch shell is blown one last time to thank the Grandmothers. Emerging from the Womb Lodge is in some ways like coming from the womb again. During ceremony time, we sit in the Spirit Place. The gifts from the Grandmothers and spirits of the four directions have brought wisdom and new perspectives into our lives. Letting our blood flow into the Earth has deepened our connections with the Mother. We have healed ourselves through our releasing in the Lodge. We have been given answers to the questions we seek. Thus reborn, each of us will take this experience back to our daily lives where changes will be manifest. The women know that during each Moon/womb cycle there is an opportunity to renew our lives. Like the Earth Mother herself, we are ever changing.

Now, the women will share in a feast. Eating together, we share the gifts of the Earth. As we have nourished our spirits and the Earth

Mother during our ceremony, now we will feed our bodies and enjoy the friendship of our sisters.

Not all of the women choose to leave the circle of the Womb Lodge. Some of the women who are bleeding will choose to stay here in the womb-space for a few hours or overnight, fasting and learning about themselves in the introspective place our womb bloods bring. While the Moon is new, she brings blood dreams to guide her sisters. It is our time for dreaming and listening to the spirit messages of the dreamtime.

The Blood Lodge is sometimes out under the stars, sometimes in our special womb room. Sometimes we meet at one of our sister's houses or in a private community space. The Women's Lodge is available at all times to any woman when she is bleeding or when she needs to retreat from everyday routines to find wisdom and stillness. Our Lodge is a safe, healing space where women can celebrate our cycles and experience the Women's Mysteries. By honoring ourselves and our Grandmothers, we create a future of harmony for our daughters. Our dance within the Lodge is the dance of our lives.

SONG OF YOUR WISE WOMB

Have someone read this meditation aloud to a group in the Bleeding Lodge, or else put it on tape so that everyone can connect their wombs together.

Find a comfortable place to sit or lie down. Rest your hands lightly on your womb. Relax and gently bring your awareness down into your womb.
Breathe deeply, inhaling peacefulness. Exhale, allowing all the tension to leave your body. Keep your thoughts clear. Do this several times.

As you breathe, pay attention to the cycles of your body . . . the short cycles of breath . . . the monthly cycles of your bleeding . . .

Let your awareness center in your womb. Become aware of your womb-space, your healing place of wisdom. Take a look around to see what's here. . .
What does your womb-space look like? . . .
Is there any vibration or rhythm for your monthly cycles? . . .

What are your special skills? . . .

What feeling is here in your womb-space on this day, at this moment, in your cycle? . . .

Listen to your womb as she tells you about this part of your cycle. Spend a short time here in this space of inner balance getting to know your womb.

Every day there are gifts and wisdom here in your womb. What is here for you today? . . .

Feel the dance of your womb and allow yourself to flow with its rhythm. Feel how this rhythm is the energy of your being, forming the cycles of your reality.

Give your womb a blessing through the palms of your hands. Spend as much time as you want appreciating your womb.

Then, gently bring your attention back to the flow of your cycles . . . the flow of your breath. Bring back all of the wisdom the healing and the gifts that were given to you in your womb-space.

Feel yourself relaxed and peaceful . . . all the way out to the edges of your body. Know that you can take this inner balance with you as you go about your everyday activities and that you can return to your special inner womb-space any time you need to hear the wisdom of your womb.

SONG OF MY SISTER THE MOON

My sister the Moon
sings her song to my womb
we dance in the Spiral of Life

Her darkness
leads me to dreaming within
we dance in the Spiral of Life

Her brightness
brings me release
we dance in the Spiral of Life

My sister the Moon
sings her song to my womb
we dance in the Spiral of Life

SONG OF FIRST BLOODTIME

There is much joy the day that the magic starts to flow in the blood of one of our daughters.

If this young woman has been coming to women's ceremonies with her mother, then she knows the honor of monthly bleeding and has eagerly been awaiting this day for many Moons. "Let's go sit on the moss over there and pretend we are the special bleeding women," she would have called to her friends in play a short while ago. But today, she announces her secret quietly to her mother, savoring this first step into a whole new reality. She will now be known as a woman like her mother.

After giving her a bath in steaming fragrant herbs, her mother helps the young woman dress in a beautiful white dress that she has made especially for this rite of passage. Long red ribbons with shiny red glass beads are tied into her braids. And around her neck, the young woman wears the necklace of garnets that both her mother and grandmother have worn for their first bleeding celebrations. The young woman is beaming, radiant, with her gift of bleeding.

Everyday chores are set aside for today. The others from the Women's Lodge have been summoned and they wait outside the dwelling for mother and daughter to complete their preparations. When the young woman comes out, they welcome her warmly and invite her to lead their colorful procession to the Bleeding Lodge. Others in the community wave blessings to them as they pass by.

FIRST BLOOD CELEBRATION

The women stop just outside the door to the Bleeding Lodge and form a circle around the young woman. This circle is the Medicine Wheel. At each of the four directions stands one of the Food Mothers. They beckon her to travel around the Wheel to hear their teachings.

The young woman enters the Wheel from the South, the place of innocence and beginnings. Standing in that direction is the Green Squash Mother, dressed in a green robe and wearing the green mask of the South with dried gourds dangling from it. The Squash Mother takes the turkey feather and blesses the young woman with the gifts of the South, innocence and open-mindedness. Lack of prejudices are here in the South and trust, and of course, the fun and playfulness of childhood. She takes the young woman's hands and they dance together, a fun and spirited dance, until they reach the direction of the West.

The Black Bean Mother stands in the West, wearing the black robe and black mask covered with black beans and hematites. She has the feather of the night bird, the owl, and blesses the young woman with the gifts of the West. Introspection, connecting with the Guardian Spirits, and self-acceptance are all here in the West. She takes the young woman's hands and they dance a dreamy, slow

dance until they reach the place of the North.

Here, the young woman is greeted by the Cassava Mother dressed all in white and wearing a white mask with crystals and cassava on it. The face on the mask is painted with the red plant juice that symbolizes sacrifice, for the North is the place of lessons and experience. The Cassava Mother blesses the young woman with the tiny hummingbird feather and the staff of the Grandmothers. With this blessing comes wisdom gained through experience and the teachings of the Grandmothers. The North Food Mother and the young woman dance a strong, rhythmic dance around the circle to the place of the East.

Facing the young woman in the East is the Yellow Corn Mother. She is dressed in yellow flowing robes, and her mask hints of a bird in flight. She is also wearing the crystal of clear sight, for the East gives the blessings of clarity and illumination. The Corn Mother takes the feather of the hawk and blesses the young woman with courage and the gift of clarity. Taking each other's hands, they dance a flowing dance, and the Corn Mother leads the young woman to a place in the center of the circle, where the women have hung the braided ropes that will become the snake.

Just as during the Equinox dances, the women prepare to dance the snake dance. Winding the braids around in a dance of weaving, they honor the fertile Earth Mother of springtime whom this young woman represents. When this part of the dance is finished, and the braids woven into the form of the snake, the women tie it to the belt of the young woman who leads them in the undulating, slithering dance of the snake. Around the circle and the Lodge they dance. Young children follow the snake, laughing and throwing flower petals. Through the new woman, the Earth Mother continues to give her gifts to the community.

At the height of the festivities, the eldest Grandmother of the Lodge breaks away from the dancing snake and leads the young woman through the East door of the Bleeding Lodge. The women follow bringing the snake, as the chanting turns into silence and the mood into one

115

of introspection.

Off to the right is a small pool of water and a small fire with sage and copal, the smudging herbs, burning on it. The sweet aroma fills the silent air of the Lodge. Carefully taking a branch of the herbs away from the fire, the Elder Grandmother makes the familiar smudging movements, surrounding the young woman with smoke. Then, she dips a shell into the water and pours it over the young woman's head and hands. The Elder Grandmother calls to the spirits of the four directions, honoring their gifts and asking them to welcome this new woman into the Sacred Space of the Lodge.

The women start a soft chant and a slow, rocking dance, while she is speaking. They have laid the woven snake at their feet in a circle. It is the womb of the Great Mother from where all life comes. They are the keepers of this sacred mystery and will pass their wisdom on to this young sister today.

When the Grandmother finishes honoring the directions, the woman next to the young woman takes her hand and draws her into the circle. Standing in front of the young woman, she speaks her own story of bleeding wisdom and blesses her. Then she gives the young woman a big hug and puts a thumbprint of her blood on the white dress. The next woman, going clockwise around the circle, draws the young woman in front of her and repeats this process. Over and over, the whole way around the circle, the young woman is blessed and becomes a sister in a new way to these women of her community. Her relatives, neighbors and older friends are all here to honor her and teach her of the Women's Mysteries. Story after story, thumbprint upon thumbprint, the women weave the magic and wisdom of the Bleeding Lodge around their daughter. Like all ceremonies that have taken place before this one, the circle of life continues unbroken and the Ancient Wisdom is passed into the future.

The last woman in the circle is the Elder Grandmother. She speaks softly and gently to the young woman, perhaps remembering

her own first bleeding time. Now, she is the wise one of this Lodge and the midwife of this young woman's transformation. She has no blood to put on the new woman's dress. Instead she gives her the staff of the Grandmothers to carry through this first night of bleeding dreams. The staff has the power of the Ancient Ancestors and has been used in the women's ceremonies a long time, even before the memory of this Elder. Painted with the ancient healing symbols of the womb, the staff teaches the wisdom of the cycles. The Grandmother is the keeper of the staff and each daughter, during her time of first bleeding, carries it to learn from the Ancient Spirit Grandmothers.

The young woman knows what a special honor it is to carry the staff and she is thankful for this time. Taking her hand, the Elder woman leads her to the most sacred place in the Lodge. This is the place where all new women first offer their bloodflow back to the Earth Mother. The ground on this spot is covered with especially lush, thick moss, and a large flat stone stands up behind it, just inside the wall. On the stone are the stains of many generations of blood prints from young women celebrating their first bleeding cycle. She has heard stories of this honored seat from the older women. All of her girlhood she has anticipated this day and this ceremony, and it seemed as if it would never come. Now she is here, pulling up her bloody skirt to sit and offer her blood for the first time back to the Earth Mother in thanks. The young woman is very happy because she can now honor the Earth Mother the way the women do each month.

Drumming starts, and the young woman journeys to the place of the Spirit Grandmothers. She is holding the staff in both hands, making the connection so the Ancient Ancestors can speak the wisdom of the bleeding times. By speaking through her newly awakened blood flow, they show the young woman her own special gifts for this Earthwalk and the path she has before her. They show her the power of her womb, sing to her the rhythm of her cycles and speak the wisdom of the Universe. Finally, the Spirit Grandmothers give the young woman a symbol of womb-power that is her own special medicine gift. Then, they

fade away and the girl returns her awareness to the Lodge. She knows what to do next.

Reaching between her legs, the young woman takes some of her blood and paints her face with the symbol of the bleeding women. She paints also the end of the staff that has already been stained with generations of first bloods. Each yearly cycle, each season the healing power of the staff becomes stronger with new gifts of first bloods. After painting her face and the staff, the young woman turns around and adds her thumbprint to the lodge-stone behind her. Like her older sisters and her mother before her, she records her mark on this lodge-stone. Some day her daughter will sit here and do the same.

"I have within me the rhythm of the Universe..." The young woman recites the sacred words linking her cycles to the cycles of the Great Mother and recognizes that through her gift of bleeding she embodies all the gifts of the Mother.

The Elder Grandmother gets up and walks to where the young woman is sitting. She holds out her hand and the young woman, still holding the sacred staff, rises and follows her out of the hut. It is nearing dusk now, and the Sun makes long shadows as they head into the trees and follow a barely marked path that goes on for quite a distance from the Lodge and the village. Finally, they reach a small hut. Made of saplings and large leaves, it looks somewhat like the Women's Lodge, only much smaller. The young woman knows that this is the place where she will spend this special night.

After giving the young woman a hug and a special blessing, the Grandmother motions her inside the hut and closes off the entrance way behind her. This is a symbolic ritual of entering the introspective womb-space of the Mother. During this night, in this space, the young woman will dream the wisdom of the Grandmother Spirits that have gone before, and they will teach her the mysteries of the womb and the cycles of life. This is the first night this daughter has spent completely alone, so she will learn more about herself on this quest.

The inside of the Womb Hut is just large enough for the young woman to get comfortable. Lying down the staff for a moment, she prepares to sit and bleed on the earthen floor. There is a candle here. Once she lights it, she also finds a rattle that was given to her as a gift to call the Spirit Grandmothers on this night and many other bleeding nights in the future when she needs to seek their wisdom. She knows her own grandmother and the Elder Grandmother of the Lodge have made it for her. It is a gourd, painted beautiful blood red with the sacred bleeding symbols on it and several small, white feathers. Beside the rattle is a shell with a thick black paste and a special painting stick. This is to add her own medicine womb-symbol to the rattle. The young woman begins to sing as she goes about this task, for she can feel the Ancient Ancestors already waiting to speak and sing with her. Her painting complete, the young woman picks up the staff, blows out the candle and sinks into the dreams and visions of her womb.

As the Sun starts to rise in the sky, the young woman stirs and awakens. Her thoughts are thick with memories of the visions and dreams of the night. She stretches and speaks her gratitude to the Grandmother Spirits. The night has been filled with messages of strength and blood wisdom. The young woman feels wonderfully renewed.

Before long, she can hear the footsteps of the Elder Grandmother as she comes down the path to the Womb Hut. The young woman begins to sing the song that the Spirit Grandmothers have taught her in the night, for then the Elder would know she is awake and ready to return. The Grandmother smiles when she sees the young woman but they do not speak. Silently, the old woman leads her back to the Bleeding Lodge to share her stories of the night.

Only women who are bleeding are in the Lodge today, so there is a much smaller circle. They welcome the new woman back into the Lodge and allow her to sit again on the sacred first bleeding place.

119

The young woman has been fasting since her bleeding began yesterday and she has been awaiting this morning feast in the Lodge. The women bring out baskets of small cakes made with sacred healing foods and pass them around the circle. Each takes one small cake from the basket of the Squash Mother, one from the Black Bean Mother, one from the Cassava Mother and one from the Corn Mother. Then, another basket with fruit is passed around the circle. Large fleshy red fruits and smaller, juicy red berries filled with seeds are the foods that the women eat here in the Lodge during their bleeding times. The red juices stain fingers and run down the young woman's chin as she partakes of this bounty. There is a red drink poured into hollow gourds and passed around the circle. Each woman thanks the Earth Mother and blesses the food before eating.

As she eats her fill, the young woman begins to speak of the dreams and visions she had in the Womb Lodge. The women focus intently on these words of first bleeding wisdom. Through the messages of this night, the young woman will know her path and purpose. The wise women listen to the young woman's stories and watch her draw her sacred bleeding symbol in the sand. They hear her sing the healing song of the Ancient Spirit Grandmothers. When the young woman has finished, the women help her interpret the experience so that she can take her messages back to her everyday life. The women talk long into the day. Often they share stories of their own first night in the Womb Lodge. The wisdom and rhythm of the Universe spins and weaves with their words.

The young woman remains in the Lodge until her bleeding has slowed. All the while she wears the white dress and sits on the special place. At night, with the red candles lit, she and the other bleeding women lie on the soft Earth and sleep within the Mother's caresses. There is no work here. All is quiet space, singing or sharing healing and wisdom.

When she finally leaves the Lodge, the young woman will be

different in many ways. She will return home to her mother's house, bathe again in the fragrant herbs, and change into a red dress. Family, friends and neighbors will gather for a feast that evening to recognize and honor her womanhood.

Most important, the young woman will be known by a new name. While in the Womb Hut, dreaming with the Ancient Ancestors, she has been shown her path and purpose in life. As she sat bleeding into the Earth Mother, the young woman allowed this new identity to come clear. By the time she is prepared to leave the Lodge and return to the community, she knows the name she will be called hereafter. The name reflects her true identity and the talents and gifts she brings to her work in life. It is a special gift from her Guardian Spirit as she passes into her time of fullness as a working member of the community. The young woman will present her new name to her family when she returns home and they will welcome her as a new woman.

As this young woman passes from childhood innocence into the awareness of her life path and keeper of the bleeding mysteries, she becomes a healer of the Earth and a wise one in her community. This is the most important passage in the growth of a woman, because she will now, each month, outwardly manifest her similarity to the Earth Mother. She will be respected for her wisdom of the cycles, her ability to connect with the Ancestors, and her knowledge of healing that is revealed in the Bleeding Lodge. It is each woman's responsibility to bring back to the community this bleeding wisdom and guidance found in the Lodge.

The women of the Bleeding Lodge honor the Earth in a special way. It is through their visits each month that they give gifts of healing and nurturing and return their blood, the gift of life, back to the Mother. This is the way the community thanks the Earth Mother for the gifts she gives them. Because the women have special ceremonies to celebrate their blood-bond with the Earth, she continues to reveal to her daughters the mysteries of the womb. It is very important to continue our lineage as keepers of this wisdom. Without the wisdom of the

womb, life would cease. Through this first bleeding ceremony, and by continuing to pass this wisdom along to our daughters, we continue weaving the fabric that is the Web of Life.

BLEEDING WOMEN'S SONG

I embrace my strong spirit
within my blood time. . . .
Through the transformation of my womb
my magic, healing and wisdom unfolds.

SONG OF PASSAGE RITE DREAM

One Moon-cycle, during my first day of bleeding, the Grandmothers spoke to me through a dream the wisdom of the bleeding rite of passage.

Sleep drifted slowly in waves; just as the first drop of my bloodflow was leaving my womb. Under the weight of the large bloodstone that I had placed over my womb, I could feel my body changing in her monthly dance. In my haziness, drifting in and out of conscious awareness, I could feel my entire body getting heavy . . . so heavy that I could not move my arms or legs. Occasionally, I could almost feel shapes brushing close by where I was lying. Quite gradually, I became aware of very different surroundings in a time way back in the ancient past.

I was lying in a hut looking up at a roof made of large, dried leaves and woven reeds. At its corners stood four supports that had been fashioned out of the trunks of trees unfamiliar to me. There were no sides or walls. As far as I could see out of the hut from my position, there were only sun and sand, with few plants or trees. In the far distance, there were a few differently constructed huts made out of similar materials. This place was like none that I had ever been in before.

"Welcome to the Women's Hut," a strong, deep voice said to me. The woman who was speaking was tall and wide, with thick arms and legs and large bare breasts. Her skin was very dark with an almost leather-like texture as if she had spent much time in the sun and wind. She projected a strength of body and spirit. Dressed in a skirt and headdress

made of reeds and brightly colored feathers, she was obviously a person of authority and power. I liked her a lot and felt as if she was someone I had known for a long time.

As if responding to my need for understanding where I was, the woman explained simply that I was in the place of women. When I began my Moon-bloods, I had been taken from the Children's Hut and brought here to join my mother and older sisters. The women were preparing a special celebration just for me. They were happy that my time had come. Afterwards I would spend my first Moon-cycle with the Strong Woman, learning the magic and healing skills that were my birthright as I came of age as a woman. Then, I would return to more celebration and feasting back at the village.

The Strong Woman says that my father and brothers are now busy constructing my own small hut. When I return, I will live alone in my own hut for one Sun-cycle. Then, I will choose a boy who has come of age to come and live there with me, just as my older sister had done last Sun-cycle.

As the woman was speaking, I began to realize why I couldn't move my arms and legs. My three sisters and my mother were each washing one of my limbs to prepare for the special ceremony. As each one finished her task, she came close and whispered a special blessing in my ear. Then they gave me a gourd of sweet nectar to drink.

Drums began a quick pulsing, as the women gathered around me and sat on the sand in a circle. They were singing a chant especially for me. The Strong Woman reappeared, her face and body painted with red symbols. She began dancing wildly in the center of the circle. I tried to reposition myself so that I could see better, but the nectar had made me sleepy and my muscles wouldn't move as I wanted them to, so I sank back down on the reed bed.

Two women entered the hut carrying a basket and set it in the middle of the circle. The Strong Woman stopped dancing and walked over and lifted the lid. Reaching inside, she brought out two

snakes, one in each hand. The second dance was much more thoughtful and rhythmic with gentle, flowing movements. As the Strong Woman danced, the snakes wound around her arms.

One by one, the rest of the women got up and joined her dance. They made a chain by linking hands to the shoulders of the woman in front of them. I could see my mother and sisters among them, and even my Grandmother was there. The women began snake-like movements, their feet stepping softly on the sand in a big spiral. Each one was smiling at me as she passed by.

The dance went on for some time. I drifted in and out of watching it. Eventually, putting the snakes back in the basket, the Strong Woman appeared again at my feet. Without words, she took my hand and led it to the space between my legs where I was bleeding. She allowed me to sense and feel my blood-gift. Then she took my hand and directed me in painting the bleeding symbols on my body. Slowly and carefully tracing the symbols of this blood-gift on my body, I became aware of the wisdom of the women. The symbols spoke to me. As I completed painting each symbol, I somehow knew the meaning of it on a very deep level. I was able to lift my head and look down at my painted body to clearly see these magical symbols.

"You *are not the same,*" Strong Woman said to me finally. *"You have remembered the wisdom. Now, you will sleep your vision sleep. I will return to teach you when the time is ready."* She slowly walked away. I could see all the other women standing in a circle around me. They were also naked now, and painted with the same powerful blood symbols as myself. The last thing I remember was watching the symbols dance as the power of the nectar overtook my awareness.

When I awoke from this powerful dream, my blood had collected on the sheet in a tiny puddle. Remembering the guidance of the Strong Woman, I reached down and began to trace the symbols one by one, awakening to the power of the women's wisdom inside of me.

127

SONG OF WOMAN SPIRIT

Woman is Strong Spirit
our power is the seed of life
we carry within
we are the cycles changing
we are the Spiral of Life

—Women's Earth Chant

SONG OF SPIRIT LIFE DREAMS

There is a place where a woman can go if she wants to invite a new spirit life to her womb to grow into the body of a child. I have seen it in my journeying close to the Great Cave of the Mother from where all life comes. The woman can enter this place only in her dreams, and with the help of the Dolphin Spirit.

The Dolphin Spirit knows the paths to traverse the depths of the waters, deeper than we have ever imagined the ocean floor, down to the Mother's Womb Cave where all spirit is given form. If she calls out to the Dolphin, the woman will be guided through these waters, for the Dolphin has guided many generations of her Grandmothers to this same sacred place. In ancient times, women who desired children knew to call upon the Dolphin to take them to the sacred shell cave to speak to the spirits. We, too, can birth the spirits of our children by doing the same.

Beginning the journey from the waters inside her womb, the woman swims out to the waters of the Great Mother. As she follows the Dolphin down into the deepest depths, a path appears marked by a curving line of shells placed in the sand on the ocean floor. There are no challenges on this path. The way is smooth and easy. Sea creatures respectfully keep the shell path clear, making way for the spirits to come into the Earthwalk. Plants on either side of the shell path are different

from the other ocean plant life, softly glowing radiant light energy from within. They light the way of the shell path as we swim deep within the Great Womb. Their beauty reflects the sacredness of this place of life and peace.

Swimming down the path a little further, the Dolphin enters a small cave. At first, there appears to be a fire within the cave, but swimming closer, the woman finds that the illumination is actually the radiance of a very large and beautiful cluster of quartz crystal. The crystal is one of the doorways of the Spirit World. A spirit in the infinite place of the Mother's womb can move through the crystal and into the woman's womb and so enter the physical dimension of existence.

The shell path ends at the crystal cluster. Directly across from its brilliant glow is a large mother of pearl shell. The shell reflects the crystal's light in soft rainbows. Its flowing curve and silky smooth surface invite the woman to curl up inside the shell and sit awhile. The woman snuggles up to the smooth comfort of the shell and prepares to meet the spirits.

First, there are offerings to be made. The woman must state her intentions for asking a spirit life to come into her womb. She must prepare gifts to honor the Great Mother and the spirit life that she is inviting. These she will lay in front of the crystal. Then she will speak of herself, so that the spirit who is looking for an Earthwalk such as what she has to offer will recognize her gifts.

When she is finished, the Dolphin begins a song that teaches the woman to call the spirit life inside the Great Womb and invite her or his presence inside her womb. The crystal carries the song messages through the infinity of the Universe.

After a while, a spirit image appears in the radiant glow of the crystal. This spirit is one who felt the vibrations of the song and is accepting the invitation to enter the Earthwalk through the womb of this woman. Woman and spirit spend a lot of time getting to know each other. Sometimes more than one spirit will respond and then

the woman has decisions to make after communicating awhile with each of them. She can invite several spirits into her womb, or bond now with one spirit and ask the others to wait until a later time.

Through the radiant beams of the crystal light, the spirit enters the womb. Once the woman has bonded with the spirit, deep connections are made between the two. Within one Moon-cycle, that spirit will begin developing a physical form.

This bond is brought back by the woman as she returns from the shell cave with the Dolphin, following the shell path back up out of the waters of the Mother to the awareness of her own womb. The woman maintains contact with the spirit throughout the entire phase of womb growth. Before the actual birth of the child, the woman may know her or his name, life path, likes and dislikes. In return, she can give the spirit teachings and gifts to make the transition from spirit to physical as easy as possible. Singing the song that the Dolphin has taught her will strengthen their physical and intuitive bond.

This dream ceremony should be done as soon as possible before or after the woman becomes pregnant.

SONG OF NEW LIFE

When a woman knows she has a new spirit life within her womb, she feels the magic of the Earth Mother's ability to create and sustain life. Like the Mother in springtime giving birth to the flowers and birds, the leaves on trees, the young animals and insects, the woman who has life within her womb radiates abundance. She knows the power of her womb in the cycles of her bleeding wisdom. She brings life into being, and then is able to feed that new life, so that it will grow. This woman knows the magic that enables the Spiral to turn into the future.

132

CEREMONY OF WELCOMING SPIRIT LIFE
INTO THE EARTHWALK

For the woman who has dreamed the spirit life dream and has prepared for the spirit to enter her womb, it is a joyous occasion when she feels the first stirrings inside her womb. The woman immediately performs her personal welcoming ceremony for the spirit life and starts the process of their bonding. She knows that it is important to bond with the spirit as soon as possible in order to begin the communication that will enable her to get to know the spirit that she is bringing into the Earthwalk, as well as teach this spirit while still in her womb.

The woman will spend much time speaking to the spirit and listening to the spirit voice. She will sing to and with the spirit life. She will meet the spirit in her dreams and teach this new one of her own medicine path. It will not be long before the woman will know if the spirit will be born a girl or boy and often the woman will also know the spirit's name and animal Guardian Spirit long before birth.

As she gets to know this new life, the woman will begin making preparations for birth. Out of a piece of soft cloth or skin, she will make a Medicine Bag for her child. Inside the bag she will put objects that she feels the child has a close connection to, perhaps a flower petal of a particular color that is special to the spirit, and a piece of her own hair. If she knows the child's Guardian Spirit, she can include a memento of that animal in the bag also. A stone from the ground near where the

child will be born will help attune the child to the Earth. The mother makes this bag slowly, over the months that she carries the child, adding each item a month at a time as the significance arises. She will wear the bag when she gives birth, so that the energy of their bonding will always stay with the child. The medicine bag will hang above the child's crib and later be worn by the child as she/he grows older and begins to add her/his own Medicine objects.

The woman also begins to make a special robe or blanket for her spirit child. As she goes through the months of growing with and dreaming with the spirit life, she will get an idea of what her child's purpose will be in the Earthwalk and what gifts she/he will bring. The symbols and stories she hears from the child within her womb will be stitched onto a soft cloth that will enwrap the child right after birth.

Once the woman begins to feel her womb stretching and growing, she consults the wise Grandmother who is the keeper of the plant wisdom. The Grandmother prepares for her the herbs to strengthen her womb and nourish both her and the spirit life. As the weeks go on, the Grandmother helps the woman understand her changing body and gives her baskets of fresh leaves, fruits and vegetables from her garden. With the help of this wise Grandmother, both the woman and spirit life grow strong and healthy.

As the time for birth draws near and the woman's womb is quite round and full, the women meet in the Bleeding Lodge to welcome the new one and prepare the mother for the birthing. All of the women gather for this occasion and each brings the gift of a feather for the new spirit life. The conch shell summons the spirits to this celebration to honor the crossing from Spirit World to Earthwalk. As the women enter the Lodge, each dips her fingers into the bowl of saltwater and purifies her thoughts, her words and her heart.

This ceremony is led by the woman who has most recently given birth. She represents the fertility of the Earth Mother and will

help this sister in the process of bringing her child into the world. This new mother who represents the Earth Mother lights the sage and copal and offers the smoke out to the four directions, the Earth and the sky. She then takes the spirit feather and smudges the pregnant woman and the womb child and all the other women in the circle.

Big, soft pillows and bright blankets make a comfortable place for the woman to recline during the ceremony. As she gets situated, the Earth Mother again passes the shell of sage and copal around the circle. As the shell comes to each woman, they pass their gift feathers through the purifying smoke four times and speak their wishes for the child's life.

The four women who are representing the Food Mothers today bring feathers that carry the blessings of each of the four directions. The Green Squash Mother gives the gift of the turkey feather that allows the child to walk the Earth in harmony and trust, having faith in her or his abilities and knowing her or his path of truth on the Medicine Wheel. The new child will enter the Earthwalk in the place of the South, with an open mind free from preconceptions. The Black Bean Mother of the West gives the owl feather that allows the child to see into the darkness of the inner self, to bond with her or his Guardian Spirit and to learn the language of dreams. The Cassava Mother of the North gives the child the gift of a tiny hummingbird feather, and the ability to learn from the experience and know that all the wisdom of the Universe is found within. The gift of the hawk feather is given by the Yellow Corn Mother of the East so that the new one can maintain objectivity and always see her or himself in relation to the rest of the Web of Life.

These feathers are tied onto a hoop made of reed to make a Medicine Wheel which will be hung over the child's crib. All of the other feathers will be hung in the child's room to bring the blessings intended for her/him and to teach the little one through spirit dreams.

Drumming begins when the gift giving is over. Each woman withdraws into her own quiet inner space where she speaks with her Spirit Guides and her Grandmothers. In this spirit place, everyone

meets the new spirit child and welcomes her or him to the clan. As the drums beat, the spirits speak. Through our wombs we can realize the link between our Grandmothers and our children, as the past and future are brought together.

When awareness returns to the circle, each woman brings back a message about the new one. The talking stick is passed around and each woman in the circle speaks of what she has seen or felt during her spirit journey. These messages are recorded and used later in the child's life for guidance and direction.

The little one is awake in the womb and knows that this ceremony is for her/him. Sometimes the mother will know or feel the response of her womb child to the messages, and she shares these with the other women.

It is time now to prepare the mother for the birth process. The Earth Mother spreads a cloth under the feet of the new mother and removes her shoes. She then takes a bowl of cornmeal from the Yellow Corn Mother and begins to wash the woman's feet. Each of the women take a turn scrubbing her feet, preparing her to walk her new path as a mother. The cornmeal is very cleansing and also makes the woman's skin soft and smooth. We are using the food of the East, the cornmeal, to nourish the woman and prepare her for her journey of motherhood. She will approach her time to give birth from the South and will walk in beauty and harmony.

After everyone has washed the new mother's feet with cornmeal, the cloth is gathered up and taken outside. It will be unfolded and the cornmeal given out as a gift to the spirits of the four winds.

The Earth Mother next takes a brush, and begins to brush the woman's hair. As each of us takes a turn brushing, we offer support and encouragement to the woman and blessings for her and the child during the birthtime. Our brushing brings strength and healing to her. We lavish her with nurturing now, as she will later give endlessly the same nurturing to her child.

When the woman is prepared and ready, we move her blanket to the center of the circle and make a place for her to lie down. All of the women surround her and we place our hands in a circle around her large womb, thumbs and pinkies touching the whole way around to form a solid ring. If the woman can comfortably reach our hands she can join us.

The women chant the womb chant. We speak to the spirit child this time through the palms of our hands. We let our energy flow into the womb and into the heart of the new one, surrounding her/him with love and peace. We let the new one know that it is time to leave the womb and that there is a family and community happily waiting out here in the Earthwalk. The spirit child always speaks back to the circle of women, sometimes by singing and always by dancing in the womb. The chant gets louder and stronger as the woman sing the turning of the Spiral that brings new life. As the chant reaches its highest energy, the Earth Mother sings out the piercing birth cries that signal the starting of the birth process. On a spiritual dimension, the new one is prepared to leave the mother's womb.

The women sit back in silence a few moments feeling the high energy. Mother and womb child are radiant. They are offered red juice to drink and prepared foods of the four directions—steamed squash, baked black beans, cassave bread and ears of corn.

Some of the women have brought gifts for the new one, and they give these away now. The mother has brought flowers or small plants and she gives each woman one to thank her for the gifts and the ceremony.

When she leaves, the new mother will go off by herself to plant the seeds of the four sacred foods as thanksgiving to the spirits of the four directions. It may be a few days or a few weeks still until the new child leaves her womb to come into our clan. As from the womb of the Earth Mother all life comes, from the womb of this woman the future generations are born.

CEREMONY
OF
WELCOMING
SPIRIT
LIFE
INTO THE
EARTHWALK

CEREMONY TO RELEASE SPIRIT LIFE

The woman who has spirit life within also knows the responsibility of motherhood. She does not accept this gift lightly or frivolously, for she knows that to accept motherhood is to make a commitment to honor that new life and to insure the nurturing needed for that life to grow. Just as Mother Earth provides for our needs and the needs of all her other children season after season, the path of motherhood requires a woman to nurture, teach, and heal her children as long as they are in need of her special care. The woman knows that each life, each spirit, is a manifestation of the Great Spirit. The woman respects and honors all life and it is this wisdom that ensures our future.

Sometimes a woman will find spirit life within her womb when she is not in a position to take on the nurturing responsibilities of motherhood. Whatever her personal circumstances, the woman knows in her heart that the time is not now. She cannot sustain this new life. When certain of this path, she consults the Elders of the Bleeding Lodge and they prepare the ceremony of releasing.

The Grandmother who is the keeper of the plant wisdom prepares for her the herbs that bring contractions to her womb. As the woman drinks the concoction, she speaks to the spirit life within. There is a sadness, of course, at this releasing. But there is

also honor. The woman expresses her thoughts as well as listening to the spirit voice within. She speaks with this spirit life many times. Spirit and woman are both in agreement with this separation. For the good of all, the spirit life gives itself away.

This ceremony, with necessary modifications, can also be performed when the spirit life decides that the time for entering the Earthwalk is not now. When this choice is made by the spirit life, the woman miscarries. She then consults the Elders of the Bleeding Lodge for herbs, healing and the releasing ceremony to ease the spirit connection between her and the spirit life that was once inside her womb.

In either case, the woman prepares a ceremonial bath. If asking spirit release, the woman is to encourage the flow of blood from her womb by making the water very warm. If she is already bleeding from the spirit release, she runs the water cool to slow excessive bleeding. The woman sings the honoring song to the spirit life, thanking the spirit for the lessons this situation has brought to her and letting the spirit know that it is time to go back. She sings to her Grandmothers for their help in this process of change. She sings to her Guardian Spirit for strength and healing. The woman visualizes the spirit life transformed and shining, on the road going back to the Great Womb Cave. She visualizes her Grandmothers coming to guide the spirit home. Floating in the water of her bath are the petals of red roses. The beauty and blood of life, the beauty and blood of her womb are those petals. Their sweet, healing fragrance aids the woman and the spirit in their separation. Her bath completed, the woman dresses in her red bleeding clothes in preparation for her bloodflow and she goes to join the other women in the Bleeding Lodge. Entering the Lodge, she places a small gift into the Grandmothers' basket. It is a gift she had made for the spirit life to thank the spirit for the gifts given to her through their connection.

The Elder Grandmother lights the sage and copal in the ceremonial shell and sends the swirling smoke out to the four directions and the other women in the circle. With the spirit feather in her hand, the Grandmother steps towards the woman and encircles her in the smoke

of these purifying herbs. Then she places the shell of burning herbs at the woman's feet. Vigorously, with brushlike strokes of the spirit feather, the Grandmother releases the woman's energy into the burning herbs in the shell. She turns the woman in several circles in the direction of undoing and brushes all of that energy into the shell. Then she turns the woman in several circles in the direction of bringing into being and shakes the woman's hands vigorously over the shell. With these actions, the ties between the woman and spirit life are undone.

The Grandmother takes the shell of herbs and the gift that the woman has made to the fire burning outside the Lodge and throws them in. The smoke that is released through their burning is the transformation of the spirit.

As the Earth Mother brings life, she also takes it back. At the end of our lives, we return to her Great Womb. The path of each individual person's Earthwalk is exactly as long as we need it to be. Some of us have longer paths than others. Some of the young animals born in springtime fall prey to the predators. Some of the young plants give away for our food or get strangled by the thick underbrush. For these sprouts, these young ones, there is always another opportunity at another time. Their spirits have learned all the lessons they need to know during their short time and they will return to the Great Womb to become reborn at another time.

Life begins . . . life ends . . . life begins again, all a part of the turning of the Great Spiral. When a woman gives back life from her womb, she is a manifestation of the Wild Mother, the one who takes back life and who calls us at the end of each Earthwalk.

To honor the Wild Mother, the women chant the releasing chant and dance the dance of the Spiral of Life. We are turning the Spiral on into the future this night.

There is one more thing that the woman must do to complete this ceremony. She must dream the spirit life dream with the Dolphin guide and see the spirit life go back through the crystal into the

140

Great Womb. So, as the Spiral dance ends, the drums still beat and the woman lies on a soft blanket in the center of the circle. The other women sit in the circle around her, rattling and singing softly until she has completed her journey.

When the woman returns her awareness to the circle, the other women wait to give her hugs. They brush her hair to give her healing. They wash her feet with cornmeal so that she may walk her path in peace and beauty. Some of the women give her gifts of flowers or small crystals, feathers or jewelry. Then, they go from the Lodge quietly, leaving the woman in the care of the Elder Grandmother who will assist the woman through her wisdom of herb use until the process of releasing is complete.

SONG OF THE CHILDREN

There are two rites of passage ceremonies that are performed by the women of the Lodge for children. Since these ceremonies are of naming and affirmation, and are rather short, they usually are performed after the full Moon ceremonies when the entire community is present.

CEREMONY OF WELCOMING A NEWBORN CHILD

Soon after a woman has given birth, at the next full Moon if possible, her new child is presented to the community. The child is wrapped in the robe or blanket that the mother has made reflecting the images of their spirit communication through the womb. A place

is made in the center of the circle with soft skins where the child is laid so that all can see her/him. The mother, or both parents, speak to the circle about the gifts that this child has brought to the clan. They also tell us the name by which the child will be known until her/his vision quest when the true spirit name will be given by her/his Guardian Spirit.

Picking the child up, the mother goes to the direction of the South where the Green Squash Mother sits. By name, the mother presents the child to the South and asks the Food Mother of the South to guide the child through trust as she/he enters the Earthwalk this first time around the Medicine Wheel. Next, the mother takes the child to the West and presents her/him to the Black Bean Mother by name asking for guidance and teachings to come through the child's dreams. Proceeding to the North, the mother presents the child by name to the Cassava Mother and asks for health and abundance in this child's life. In the East, the mother presents the child by name to the Yellow Corn Mother asking for clear vision for the child in following her/his life path.

The Clan Mothers and Elder Grandmothers come into the center of the circle to bless the new child and welcome her/him into the circle.

CHILDREN'S NAMING CEREMONY

When a child reaches the age of about three years, the Food Mothers, Clan Mothers and Elder Grandmothers again gather to bless the child and affirm her/his gifts and talents. By this time, the child has developed interests and has become rooted in this Earthwalk. Now, the time has come to review the message from the womb welcoming ceremony so that the child can remember her/his purpose for entering the Earthwalk. If the child wishes, she/he is given a chance to speak to the circle about whatever she/he wishes to share.

The Elder Grandmothers give the child a new name reflecting her/his interests or abilities. This name becomes added onto the child's birth name. The Grandmothers each bless the child and give her/him a gift. Once again, the mother presents the child to the Food Mothers, using the child's full name, and asking the four directions to continue giving this child their gifts and blessings.

This is the last time that boys will be honored in the Women's Lodge. After this ceremony, boys become part of the Men's Lodge and will follow the ceremonies of the men's passage rites.

Girls continue to grow up under the guidance of the Grandmothers of the Lodge of the Elders. The teachings given to the girls will prepare them to enter the Bleeding Lodge when they reach the next passage rite at the time of first womb blood.

SONG OF THE BLEEDING SHAMAN'S JOURNEY

When the drumming starts, I can feel my spirit begin to soar. Pulsing through my body, the rhythmic voice of the drum opens up my senses to allow the spirits to speak through my movements. Like the wings of a giant bird, my arms flow through the air in the dance that is taking my spirit body past the clouds and through the rainbow circle that is the gate to the Spirit World. Losing touch with all that is familiar except a small spark of awareness, I traverse the darkness, flying in trust with the eyes of instinct.

As images become clearer, my flight returns to dance. I am aware of my body movements in a free, pulsating rhythm and as I look down, I am now faced with the body of a large spotted feline. With animal form and grace, my dance becomes the undulating poetry of the merging of two wild and free spirits. With the awareness of the cat, I can know strength and gentleness and I can see into the ancient times.

As I dance and rattle, I realize that I am not alone. Others, many others, are dancing with me, and they reach out to include me in their song. I look into the faces of the ages, the faces of wisdom and magic. They are many Grandmothers. Faces of every color and bodies of every imaginable size greet me. Their wrinkled skin, like the rings of trees, bears the knowledge of life. The eyes of these Grandmothers shine with healing magic and they beckon me to join their outstretched hands.

145

We dance together, winding in a spiral like a huge snake. In the darkness, dancing down a tunnel, going deeper with each turn, we make our way to the Womb of the Mother. Like my mother, her mother, and her mother before her, I enter into the initiation of the Grandmothers.

When we finally reach the cave, it appears to have no specific size or shape, yet encompasses both nothing at all and all that ever was, is, or will be. I stand in the center while the Grandmothers form a circle around me.

One of the Grandmothers steps towards me. I recognize her as one of my own ancestral Grandmothers. She holds a shell filled with salt water from the tides of the oceans and she sprinkles the water to each of the four directions. Then, she pours what is left in the shell over my head. I perceive a sensation as if I am standing underneath a waterfall then I realize that I am being bathed by the tears of all the Grandmothers. Their crying brings release and cleansing to my spirit.

Again I look down at my body, and this time I see my woman's body, naked, beautiful, and fragile, as all life is created. A manifestation of the Great Mother. She says, *"I am Constance, your grandmother and mother, and I bless you with the blood of life, strength, healing, and magic."* From a clay bowl she leaves a thumbprint of her blood on my womb.

Then, all of the other Grandmothers approach me and leave me imprinted with their blood, and the knowledge of the mystery of the ages. They have painted the sacred women's symbols on my belly and breasts. Each of the Grandmothers leaves her thumbprint, and I am covered with blood of many shades and prints of many shapes. By the power of their separate gifts, they have taught me wholeness.

Chanting the womb chant, the Grandmothers begin dancing around me again. In celebration, Grandmother Constance places the special shell necklace around my neck. This gift represents my connection to the Moon and the sea. She also gives me a ceremonial staff

with the bleeding symbols painted on it and a red rattle to communicate with the bleeding symbols during my bleeding time. Through these sacred gifts, the Grandmothers honor the blood of their granddaughters.

The circle of Grandmothers again becomes a spiral. We sing and dance our way to a very large tree at the entrance to the cave. Grandmother Constance tells me to give a gift of my blood back to nourish the Earth Mother. I am honored to return my nourishing womb blood and sit for a while in silence contemplating the gifts and insights of my bleeding time.

All the Grandmothers have gone except for Grandmother Constance. She instructs me to follow this ceremony each month at my bleeding time and to share it, so that other women may come to remember the specialness of their womb blood. She says that the other Grandmothers are waiting for their granddaughters to return to the Great Womb to honor them and accept their gifts.

The wisdom of the Grandmothers is that all is found within. It is by fully accepting and honoring ourselves and our cycles that we gain the ability to heal ourselves and live life to its fullest abundance.

SONG OF BLOOD'S END

The ceremony of honoring the wise woman is performed at the time when a woman has stopped her monthly bleeding cycles and feels ready to enter the Grandmother's Lodge. There is a special place in the Bleeding Lodge for these keepers of wisdom, the women who no longer bleed.

The bleeding women enter the Lodge to give blood back to the Earth and dream spirit dreams. They bring the wisdom of the Ancient Ones back for healing of the people and relations of the clans. Their cycles of bleeding give them access to the secrets of the ages. During their special time, the women bring these gifts back to the community, so that our lives can benefit from the experiences of our Ancestors.

The wise women and Elders have a very special role in the Bleeding Lodge. When women stop bleeding, they hold the wisdom of the Ancestors inside their wombs at all times. Every day of the month, these women have the power to heal through their wombs and communicate with the Ancient Ancestors. It is these wise women who oversee the caretaking of the Earth and the harmony of life within the Sacred Web. Looking beyond personal and clan relations, these women are actually the ones in our world who hold together the Sacred Hoop and take offerings to the Sacred Tree for the benefit of all life.

The wise women have grown through their experience at each bleeding cycle and thus are the teachers and keepers of the wisdom of the Ancestors. Some of them have given birth, and all of them have learned healing and wise knowledge through the lessons of their lives. During the years of their bleeding cycles, they have cared for their children, their gardens and those in their community. Now, in the Grandmothers' Lodge, they turn their attention to the care and healing of the Earth Mother and the rest of our relations in the Sacred Web of Life.

It is these wise Grandmothers who remind us to live in harmony with the Earth, honor the Tree of Life, and make all of our actions benefit seven generations of our grandchildren. It is through the special ceremonies of this Elders' Lodge that balance is maintained between the human children and the Mother Earth. These wise teachers pass their knowledge to the children to ensure that the Ancient Wisdom survives into the future.

A woman of any age can enter into the Grandmothers' Lodge whenever she has stopped her blood cycles and feels prepared to make this transition. Some younger women cease their womb bleeding early and through unnatural means, since our technology allows us the choice of removing our wombs to eliminate the pain we hold there. If that is a woman's choice, she too has the right to enter the Grandmothers' Lodge and become initiated in the sacred responsibilities of caretaking the Web of Life and teaching the wisdom of the Earth.

However, the woman who finishes her blood cycles early must first be sure that she has also finished learning the lessons of her bleeding time before going on. Body and spirit must both be prepared to enter the Lodge of the wise ones. For this reason, every woman also has the choice to stay in the Bleeding Lodge as long as she feels is necessary to complete her personal growth.

This woman can still feel the Moon cycles and her body's monthly rhythms, even though she no longer bleeds. She can select her own personal time of the month where she can feel her inner power, perhaps

the new Moon or the Moon phase when she used to bleed. During this chosen time, the woman can connect with the spirits of the Ancient Ancestors and perform a ceremony of gratitude to thank them for their continued teachings and guidance. She can celebrate her transitional time by making alterations in her bleeding clothes and blood time medicine objects to reflect her new womb-phase. Although no longer participating in the special ceremonies for bleeding women only, this woman remains a part of the Bleeding Lodge as long as she feels is necessary. Whenever she feels that the time is right to move into the Grandmothers' Lodge, she will begin to prepare for this wonderful rite of passage.

WOMAN'S PERSONAL CELEBRATION OF BLOOD'S END

The first part of this ceremony is a personal one, performed in preparation before the woman asks for a ceremony in the Grandmothers' Lodge. It should be done in an outdoor place that has been special to the woman and preferably where she has spent time during her blood cycles honoring the Earth and giving back her blood-flow. This is a personal holiday and the woman allows the entire day to honor her Grandmothers, the Earth, and herself. She takes a basket filled with the sacred foods, seedlings of young trees to plant, and offer-ings to the spirits and her Grandmothers with her to the site. She also takes a container of water and some of her favorite bleeding medicine objects, especially her bleeding rattle, as she plans to sing to the spirits this day.

On arriving at the site, the woman makes a small circle of twenty-eight stones that she finds nearby. This construction of her own personal Medicine Wheel creates the Sacred Space in which she will perform her ceremony. She sits in the North now, the place of wisdom gained through experience. Unpacking her basket, the woman pours some of the water into a shell that she will use for purification and then, turning to each direction, she makes offerings of the four sacred foods and gives thanks to the Food Mothers for the gifts each of them has brought during her bleeding cycles.

SONGS
OF
BLEEDING

Picking up her red bleeding rattle, the woman sings her power song, the special chant taught to her by her Guardian Spirit to call upon her blood power and the wisdom of the Grandmothers. As her song becomes stronger, the woman rises and begins to dance, slowly at first, as she calls her Guardian Spirit near, and then faster and faster as she gives her body to become the movements of her power animal's dance of life. Woman and spirit are one, healing, power, and wisdom flowing through their connection. After awhile, the woman stops rattling and sinks back down onto the Earth to contemplate the gifts of this exchange.

The woman will perhaps lie awhile to dream spirit dreams at this special time in her sacred place. When she decides to go on with her ceremony, she reaches into her basket and prepares to give her offerings to the spirits. First, she takes some of a plant that has been a special healing plant for her, and offers it as a give-away to her Guardian Spirit. She may bury the plant in the Earth or simply find an appropriate place to leave it, such as in the forked branches of a tree, so that her Spirit Guardian may find it after she is gone.

The woman has brought a seedling of a tree for each one of her grandmothers who has helped with Moontime dreams and visions to teach her the Ancient Wisdom. All of the women who have gone before us are our Grandmothers, all the same family. So, the woman may have many Grandmothers to honor this day.

Holding each seedling, she sings with her rattle to honor a particular grandmother and ask that her spirit continue growing through the life of the young tree. Then, rising, she searches for a spot that is just right for a home for this tree. When she finds it, the woman begins to gently part the Earth, telling the Mother her intentions and asking her to nourish the small roots so that the tree can grow strong and tall. As she works, she sings also to the spirit of the Grandmother, remembering special powerful teachings she has received from that particular Grandmother, thanking her and strengthening their connection. The woman makes an offering into

the hole and also leaves a piece of her hair to nurture the new plant. She covers the roots with Earth, offers some water and blesses the plant so that it will grow strong and abundant. This process she then repeats for each of her female Ancestors, Spirit Grandmothers or living sisters that she wishes to honor and thank.

When all of the seedlings have been planted, the woman returns to her circle. Along the way, she gathers gifts from the Earth that may call out to her. They are gifts from the Grandmothers. The woman will make something special for herself from these objects to wear at her initiation ceremony, perhaps a feather or flower crown or a pinecone necklace.

The woman stays in her stone circle as long as she wants, perhaps playing music on her flute, or just listening to the songs of the feathered ones. She spends the rest of the ceremony contemplating her own personal growth through her bleeding medicine. She will bury any cloths or sponges that she may have used during her bleeding times.

When returning home, she will recycle her red bleeding clothes into a shield which will represent the lessons she has learned through the power of her bleeding times. Throughout her blood cycles, the woman has worn these special clothes to celebrate her bloodflow. Since she no longer has a blood flow, she can use the shield to call upon her bleeding wisdom in the future. After making her shield, she will go to the place of the Elder Grandmother and ask for the ceremony of initiation into the Lodge of the Grandmothers.

INITIATION CEREMONY INTO THE GRANDMOTHERS' LODGE

On the day of her special ceremony, the woman prepares by purifying herself. This time, she rubs her body down with cornmeal to cleanse her body and spirit and prepare for her transformation. She gives the cornmeal back to the Earth. Now, she will dress in white when she goes to the Lodge, like all of the other Elders. With her red bleeding shield and her basket full of flowers and small gifts, she goes to the Women's Lodge.

All the women are there to celebrate the special occasion when their sister is welcomed into the Grandmothers' Lodge. Those who are bleeding have their faces painted in the traditional way and are wearing their red bleeding clothes. The Grandmothers and Elders are dressed in white. They do not have their faces painted, but rather wear a single feather in their hair, each woman wearing the feather of the bird that is her teacher of wisdom. All of the women wear shell necklaces and some wear belts of woven red cord from which shells, tiny crystals, and medicine objects hang. The Grandmothers and wise women who no longer bleed carry baskets filled with offerings and medicine objects. They all join hands to form a circle around their sister, dancing and singing the women's chant.

The Elder Grandmother blows the conch shell to summon the spirits of the four directions to the ceremony. The dancing stops and

she goes around the circle with a shell of burning sage and copal to smudge each woman there. The water bowl is passed around and each woman purifies her thoughts, her words, and her heart.

The woman takes the flowers from her basket and goes around the circle, giving each of her sisters a flower and thanking each one for the special gifts and knowledge that she has given to her while they have shared bleeding cycles together in the Lodge. When she has finished her give-aways, the woman stands at the South of the circle facing the Green Squash Mother.

The Food Mothers play an important part in this passage rite. Wearing their masks of the four directions and brightly colored robes, they represent the gifts and teachings from the Medicine Wheel that this woman has contributed to the Bleeding Lodge and the people. In this special ceremony, they thank her for the give-away of her blood during each Moon cycle.

Reaching into her basket of sacred food, the South Mother gives the woman a dried gourd, the symbol of innocence, open-mindedness and trust of the South. The Green Squash Mother reminds the woman of the gifts she has brought to the Moon Lodge to teach others of innocence, trust in the spirit and acceptance without prejudice. She thanks the woman for the laughter and fun that she has brought to the Lodge. She blesses her with the turkey feather of the South and reminds her that, through this passage, she starts again on a new cycle around the Medicine Wheel.

The woman goes to the place of the West and stands before the Black Bean Mother. The West Mother gives the woman a handful of dried black beans and reminds her of the special gifts she has given the Lodge through the insights and prophecies of her bleeding dreams and visions. She thanks her for giving the gifts of her blood times to the people and the Earth Mother. The Black Bean Mother tells the woman that she will now be known as a keeper of Spirit Wisdom. She blesses the woman with the owl feather of the West.

Next, the initiate goes to the North and greets the Cassava Mother.

The North Mother gives her a piece of cassave bread and thanks the woman for the wisdom she has shared with the others in the Lodge during her cycles. The North Mother also thanks the Grandmothers of this woman who have taught us all through the woman's blood connection. The Cassava Mother blesses the woman with the tiny hummingbird feather and tells her that now she will be known as the keeper of the wisdom of the Grandmothers and will pass the Ancient Wisdom of life to our children through their teachings.

Finally, the woman is at the East standing before the Yellow Corn Mother. The East Mother gives her a handful of dried corn from her basket and reminds the woman of the gifts she has given to the Lodge during her blood times that help to reconnect the Sacred Web of Life. She thanks the woman for the strength and illumination that she has shared in the Lodge so that all of her sisters could grow. She thanks the woman for all of the wonderful inspirations she has contributed to the Lodge through her blood cycles. The Yellow Corn Mother blesses the woman with the hawk feather of the East and tells her that now she will be known as the keeper of the Sacred Web, the weaver of the future.

The Elder Grandmother presents the woman with the staff of the Grandmothers to use during this special night. As she was so honored during the ceremony of her first blood, the woman will again carry the symbols and blood-medicine of the Lodge and she will represent the presence of the Ancient Grandmothers in the ceremony.

All of the women sit down inside the circle of twenty-eight shells. The new Elder puts on the shells, mask and robe of the Earth Mother. She leads the women in a ceremony to send healing to the Earth Mother, extending their circle of bleeding energy beyond their own clan to include the planet and all of our other relations.

At the end of the ceremony, the Elder Grandmother gives the woman a drum. Now, she will retire her red blood-medicine rattle and use the drum of the Grandmothers to communicate with the

spirits of the Ancient Ancestors through the heartbeat rhythm of the Universe. Through the drum, the woman will send out her teachings through the Sacred Web to awaken the children and grandchildren to their connections.

INITIATION
CEREMONY
INTO
THE
GRAND-
MOTHERS'
LODGE

The woman prepares to go off now for an all night dream quest. She has been fasting today and, entering into this new passage, she will repeat the quest of her girlhood when her blood first began to flow. She removes the mask, shells and robe of the Earth Mother and taking her new drum, her red shield, and the Grandmothers' staff, she walks out of the shell circle and down the familiar path leading into the woods to the Womb Lodge. The other women in the circle chant the chant of the Grandmothers to ask that they grant the woman their wisdom and teachings this night. They wish her clear visions by throwing flower petals in her path, as she leaves the Lodge.

She follows the trail of the deer and the calls of the birds as she makes her way down the long path. Finally, she sees the Womb Lodge up ahead. Facing the sunset, the wise woman pauses to honor the spirits and thank them for this day before she enters the Womb Lodge.

There is a candle waiting for her inside and, when she lights it, she also finds a shell with black paste and a shell with red paste and a few painting sticks. With these, she will paint her new medicine symbols on the drum. The woman smiles as she remembers her enthusiasm that night long ago when she painted her bleeding rattle. Tonight she will put the paint aside and take her time contemplating her bleeding days and speaking with the Grandmothers before she paints her drum.

The woman makes herself comfortable in the small hut, blows out the candle, picks up her drum, and begins to sing to the Grandmothers. She sings of thanksgiving and celebration. She honors all of her relations in the Sacred Web through her song. Late into the night she sings, until dreamtime calls and takes her to the place of vision where she will learn of the changes in her path and the new gifts she will bring into the Lodge of the Grandmothers. She dreams of spinning the Web of Life with her Ancestors of the ancient past and her great-grandchildren of

157

the future. Through her dream dance, the Ancient Ancestors speak and tell her of her own personal task as caretaker of the Earth. The Grandmothers give her a new healing symbol, for now her work has changed, as her cycles have. The culmination of all her years of blood cycles becomes this woman's everyday ability as healer and caretaker of the Earth.

In the morning when she awakens, the woman mixes up the paste and paints her new medicine symbols on the drum. Not only has she learned more about her changing self this night, the Grandmothers have given her a new name. As she paints, the woman remembers her times of bleeding and the work she has done. Surely, she has gained much wisdom from her experiences since she last spent the night visioning in this same Womb Lodge and was given her first spirit name.

The paste dries quickly and the woman prepares to leave the hut. Stepping outside, she holds the staff of the Grandmothers out to each of the four directions to welcome the day and thank the spirits for the gifts of the night. Then, she walks back up the path to the Women's Lodge, taking her time to listen to the wisdom calling through the rustle of the leaves and the singing of the birds.

There are only the Elders left in the Lodge this morning, waiting for the woman to return to speak of her experiences of the night. While the woman was fasting, they have been preparing a big feast. Baskets are piled high with freshly made breads and bowls of the sacred foods have been cooked and are steaming warm. Herbal brews fill the Lodge with sweet and gentle fragrances. The Elders welcome their sister as a keeper of the Ancient Wisdom as she sits for the first time in their Lodge.

As they eat, the woman recounts her visions and dreams of the night, the messages from the Ancient Ancestors and her path of caretaking the Earth. She shares with her sisters the new name by which she shall be known and the symbols she has painted on her drum.

After she has finished speaking, the staff of the Grandmothers is passed around the circle and, one by one, each of the Grandmothers and wise women speak of their own special wisdom and path of caretaking the Earth. Each one gives the woman a small medicine gift to keep in her basket and the woman gives away the gifts she has brought in her basket to these wise women. The women talk late into the day, integrating the contributions of their new sister into their Lodgework.

The women in the Grandmothers' Lodge are the keepers of the wisdom of the Earth and the Ancient Ancestors. They have their own medicine, sacred objects and teachings that are shared only with the other wise women in this special Lodge. The Elders or Grandmothers' Lodge has special ceremonies and healings. From this Lodge, much work is done on planetary energy to bring healing of the Earth and of the Sacred Tree.

Although the Grandmothers and wise women meet with the other women of the Bleeding Lodge for ceremonies and celebrations, the special work of the Elders is to listen to the Earth's Cycles and make sure that the people act in harmony with her needs. They are the caretakers of life and teachers of the children to ensure that harmony and balance be brought into all situations and all interactions. It is from these wise ones that the people seek counsel in times of trouble or need, for the guidance of the Elders is considered the voice of the Ancient Ancestors.

No matter what her age, the woman who has stopped bleeding leaves the night in the Womb Lodge a respected Elder and teacher in the community. She will be known by her new name and people will honor her wisdom whenever they need advice or healing.

SONG OF TRANSFORMATION

I can hear the call of the Mother
gently guiding me back to her womb.
I know my time in this body is about to run out
and I look for the path to take me home.

Come gather around me
children, sisters, friends.
Let me share a final bowl with you.
Let me finish each of our stories
and sing each of you a song of thanksgiving
for walking beside me on this path.
I know the Mother is waiting,
but each dying spirit is granted one last wish
and my wish
is to sing a farewell song to you, my family.

I will take the memory of our circle with me
when the song is over and I rise to leave
with nothing but my rattle and my shield.
Smiling, already fading,

I give each of you a hug and a gift.
And then turning, without looking back,
I walk into the West.

I will go to my Sacred Space
and sing my death song
honoring all the spirits who have guided my steps,
taught me my lessons,
and showed me the beauty in the world around me.
Singing and rattling,
honoring and thanking,
finishing my Earthwalk.

My life has been a give-away;
each day I gave my very best
to the dance of life,
to the weaving of the Web.
And now death is my last give-away.
Giving away my body
to create life for the future. . .
Giving away my spirit
so that wisdom may survive and grow. . .
Giving away my death
to the living. . .
Giving away with honor.

I will sing until the time has come
when my Spirit Guide beckons

and we, two spirits now,
start down the trail that leads back to the Great Womb.

It is a familiar path.
Long ago, at the start of this Earthwalk,
I remember coming down this path.
The way is easy now. . .
Going home to the Mother.
I take my time, savoring each final memory of beauty
changing . . . transforming
into Spirit Song.

At the end of this path is the opening to the cave,
a big door
separating the dance of life from the place of regeneration.
Only in death can a spirit cross this threshold,
for there is no turning back.
Once inside, the spirit transforms,
becoming again everything that is. . .
encompassing all of the Universe. . .
Knowing all, seeing all,
total oneness inside the womb.

When my spirit transforms, my children will know.
I will ride on the night wind
and speak to their hearts of my change.
In the morning they will come to get me,
ringing bells so that my spirit will know

they are taking care of my body.
All day my family will spend with me,
our last day.
They clear a place in the woods
and build a wooden platform
from already dead branches lying about.
Then, they gently place on the platform
my peaceful body
with my rattle and shield.
Setting the fire, they chant for me.
Singing the songs to guide me
down the path,
back to the Womb.
Singing the song to let the doorkeeper know
I am returning home.

They release me,
tears of sorrow and joy,
and honor memories of times past.
Each one eats the fruit and plants the seeds
to remember me by.

When I die, my children,
release my spirit by fire
to ride on the winds
into the four directions.
When the ashes cool,
give them back to the Earth

so that I may become
a part of the trees, the flowers, the brook.
So that our relations can eat and grow strong
on the gifts of my give-away.

Remember me, my sisters
when blood flows from your womb.
Remember how I have given life,
danced beside you,
spoken my wisdom and taught you my skills.
Allow my spirit to stay alive
on your altars
and in your hearts.
And I will hear your song
and guide you from the other side
when you ask my wisdom.
Remember me, my children
and wisdom shall be given to you.
Remember me and you shall know
the place from where you came.

Forever changing and transforming,
the Web of Life
continues to weave anew.

No matter how we choose to die, we will each sing a song of death when we realize our time is up and start preparing to travel back to the Womb of the Mother.

Death is the most personal of the passage rites. It is the time when we assess all the work we have done in our lives. At birth, we each have been given special talents and gifts to utilize in performing our life tasks. The lessons we have learned and the choices we have made to use these gifts are what we will leave to our children, our families and clans, and the Earth herself after we have gone.

For a brief time before death, we enter the place of the East—illumination and clarity. The struggles of learning the lessons of the North are over, and we are able to detach from the activities of life, so that we can objectively look at the use we have made of our gifts of birth to fulfill the work we each came into this Earthwalk to perform. Finally, we are able to see the events of our lives whole and connected, as a tapestry of the activities of all of our days. The meaning and value of each activity, no matter how small, is revealed in this image. Everything is drawn together as we enter the place of the East for the last round around the Medicine Wheel in our physical bodies.

This is the time for releasing, letting go of the attachments and limitations of our physical realities. We will no longer need them as we move into the Spirit Place. Any unfinished business or words unsaid needs to be resolved during this time to make our transitions smooth. Our cycles complete, we must finish up relationships with family and friends. Then, we are ready to move into the place of the West and enter into the darkness to walk the spirit path back to the Great Womb.

Gently letting go of life is a celebration that each person performs in their own way. Although the cycle of life is ending, the path of the Medicine Wheel goes on and each of us will return to the Great Womb only to be transformed and reborn in another physical form. We welcome this change and know that our spirits are a part

of everything that is. *"In the sacred circle, life unfolding goes round and round. . ."*

The first death song is a personal ceremony, a realization of life's ending by the dying one, and a song of thanksgiving to the spirits for all of the gifts of this Earthwalk. The death song prepares us to return to the Mother. It is the beginning step in the process of transformation of the spirit.

Even if a woman is lying in a hospital bed, she can perform her death song. We all have a right to prepare for death in our own way. As we approach our time and begin to plan our personal ceremonies, our death songs will be made known to us. Each woman's passage is uniquely her own, just as her life has been.

Our Guardian Spirits make a firm connection during the death ceremony, so that they can guide and protect us on our travels back to the womb-place of transformation. This first ceremony of death, the celebration of life, is always done alone by the person who is preparing to die.

CEREMONY OF RELEASE AFTER DEATH PASSAGE

The second ceremony of death is the one of remembrance. This ceremony is privately performed by family and friends as soon as possible after the woman has passed into the Realm of the Spirit.

The ceremony of remembrance is always done out of doors in a place where we can be alone and feel connected to the Earth Mother. Young children perform this ceremony with their mothers, so that they can learn of the time of passage back to the Great Womb. Although this ceremony is usually a time of quiet contemplation, we feel free to honor our departed sister in any way that reflects the relationship we have had with her, and the gifts she has given us while she was living.

Once connected to the Earth Mother, we begin our song of remembrance. All of our memories of the past relationship are in the song. We sing of happy times together, the work we have shared in, the gifts we have given each other and the beauty that was created because of our knowing the person who has died. We thank the woman for her life and sing of how our spirits have connected these past few hours before death. If anything remains unfinished between us, we sing its resolution in our song so that her spirit may move unhindered on her path. By integrating and completing our physical relationships, this ceremony allows those of us who have

shared a part of the path of this woman's Earthwalk to transform our connections into a spiritual dimension.

After singing, we will eat the food of the dead. An apple or any red fruit symbolizes the blood of her life. Eating silently, we internalize all the gifts this person has given us, all of the ways in which her life has nourished ours. Her gifts and her spirit will live on in the thoughts, words and actions that have been influenced by the time we have spent together. By the time we have finished eating the fruit, we know how she lives on through us.

Taking a stick, a small hole is made in the Earth near where we are sitting. We sing to the Mother for rebirth of our loved one, as we gently part the Earth to receive our gifts. One by one, each of the seeds from the fruit is dropped into the hole. With each seed is a blessing from us, a wish to help this spirit woman on her travels in the beyond. Other gifts too are placed in the Earth for this woman. A piece of our hair is part of ourselves that she can remember us by. A flower will remind her of the beauty and fullness of her Earthwalk. A leaf from a special herb will symbolize the healing she has given us. A small whistle would symbolize her love for music or a small piece of lace, her needlework hobby. When all of our gifts have been given, we gently replace the Earth to cover the hole and thank the spirits of this special sacred place for allowing us to perform our ceremony here.

We take our time and leave this place slowly, observing the plants, birds and animals around the area. The spirits of the dead speak on the wind, in the calls of the crows and through the rustle of plant leaves. In the space of silence after our song, we listen to hear a response from the spirit woman.

In the first few weeks after death, the spirit stays close to these special people that she was close to while living. They need to communicate with us, just as we need to remember them as they go through the phase of transformation. The spirits speak through our dreams, especially during our blood cycles, and through signs in the world around us. We need only to listen to hear their familiar voices.

We take our time these days, allowing everyone to perform the remembering ceremony at their own pace and allowing our lives to adjust to this change.

CEREMONY OF HONORING THE DEAD

After everyone has completed their private ceremony of remembrance, we come together to perform the last ceremony for this departed sister: the honoring ceremony. This is the ceremony of letting go, for through it we allow our relationship to be transformed. If the person has recently crossed over, this ceremony opens the door to keep us in contact with her spirit. We can also perform this ceremony to awaken a connection with an Ancient Ancestor who had lived long before we were born. When the spirit ones hear our songs of honor, they are pleased and know that we have not forgotten them.

The conch shell calls the people, and the spirits, to the circle to begin the ceremony. All of the spirit woman's family and friends gather to sing the honoring song for her. This is a community ceremony led by wise Elders from the Grandmothers' Lodge. The Elder Grandmother manifests the presence of the Wild Mother who welcomes life back at the end of the Earthwalk. The Elder Grandmother knows the wisdom of the Wheel, and she teaches us through this ceremony that life never ends, but is continually transforming. The four women representing the Food Mothers are also from the Grandmothers' Lodge. They embody the gifts and teaching given to us by the spirits during our lives. We do not use the masks in this ceremony. The Food Mothers simply sit in each of the four directions in our circle with their baskets of sacred foods.

The Earth Grandmother lights the sage and copal and smudges the four directions, the Earth and Sky, and all the women present. We sit for a few moments in silence, allowing our thoughts to drift with the smoke out into the Spirit Realm.

Two vases in the center of the circle have been filled with the flowers we have brought to remind us of the beauty that this woman gave to us during the days when she walked by our sides. Next to the vases is a large bowl filled with salt water and some of the woman's favorite flowers have been snipped from their stems and are floating in the water. Also drifting on the water is a small piece of wood, a symbolic boat that carries the woman's physical essence on the waters back to the Great Womb, place of rest, transformation and rebirth.

We bring rattles and shake them throughout the ceremony to let the spirit woman know we are honoring her and to give her strength. Each person also brings a white candle and we each light them and place them in a circle around the flowers and water bowl. The light from our candles will help guide our spirit sister back to the womb easily. They must burn the whole way down without being blown out, for to darken their light may slow our sister's journey.

We begin the ceremony by sharing our memories. A special object belonging to the spirit woman, perhaps a comb or a piece of jewelry, is used to invite her presence into our circle. If it is impossible to obtain a personal item, we can use an object that is symbolic of the woman's life path, the gifts she has brought to us, or even a flower. Taking this object and a small photograph of the woman, the Earth Grandmother begins the story. She speaks about a special time that she has shared with the departed one, a fond memory of their friendship at a time long ago when they were both just young girls playing in their mother's gardens. When she has completed the telling of her special memory, she looks at the picture and speaks of the things she wishes her to hear at this time. She thanks the woman for

her friendship and speaks of the love she holds in her heart, and will keep in her heart, for this dear friend. Then, she passes the picture and the special object to the woman seated on her left and softly shakes her rattle.

The next woman tells her story, her own special memory of the departed sister. Perhaps she will tell us how the woman taught her to knit or gave her special plant recipes. Perhaps she will just remain silent, speaking from her heart. As the objects make their way around the circle, a total picture of the spirit woman's life is revealed through the remembering of the gifts she has given to each of her children, her family, and her friends. Tears of sadness and tears of joy sometimes accompany the storytelling, as we let ourselves grieve for the loss of our friend. Through the telling of our stories, we honor her Earthwalk.

While the people are speaking, the Elder Grandmother constructs a small hut out of dried cornhusks. Having four sides, each facing one of the four directions on the Medicine Wheel, a floor touching the Earth and a roof pointing up to the sky, the hut represents the Womb of the Earth Mother to which the dead woman is returning. When she has built the base of the hut, she places it on the floating wooden block.

At the end of the storytelling, when the special object and photograph circle back around to her, the Grandmother says her good-bye to the woman as we have known her, folds up the photograph and places it inside the cornhusk hut. Other small objects representing the spirit of the dead woman are also placed inside the hut: a piece of her hair or perhaps a thread from her shawl, a petal from one of her favorite flowers or pieces of other objects that represent her life and her spirit. We shake our rattles as each is put inside the hut.

The Food Mothers each place a piece of the sacred foods inside the hut to represent the woman's path around the Medicine Wheel during her Earthwalk. The South Mother, Green Squash Woman, places a piece of dried gourd into the small hut and tells the circle something that the woman has done in playfulness and trust during her lifetime. The Black Bean Woman, West Food Mother, places a black bean in the hut and tells

us of this woman's Guardian Spirit and the gifts that she received during her life from the place of the West. The Cassava Woman, North Mother, puts a pinch of cassava powder into the hut and speaks of the work that the woman has done, the hardships she may have survived and the wisdom that she has left with us. Finally, the Yellow Corn Woman, East Mother, places a piece of corn in the hut and speaks of the strength of our sister and the inspiration that she has given to all of us who remain on the Earthwalk.

The cornhusk roof is placed on top of the hut filled with our memories of our sister. The Earth Grandmother lights the fire that transforms her physical essence into spirit. We sing a song of releasing, as we watch her change and transform through these flames. Fire floating on the bowl of water in the center of our circle lets us know that our sister is returning to the Womb.

We cry the tears that bring our own cleansing and transformation. Water flowing out of our hearts and down our cheeks becomes the waters that carry her spirit back home. As the fire cools to ashes, the change becomes complete. Putting our arms around each other, around the circle, we console each other and strengthen the web of the living ones.

Each of our relationships with this sister has been transformed into the realm of the spirits. The Earth Grandmother comes around the circle with the spirit feather and holds it lightly above each of our heads for a short time, silently opening the channel through which we can invite this woman's wisdom to come through in the future for guidance and healing.

When she returns to her place in the circle, the Grandmother puts together the memory board. A narrow piece of board about a foot long has already been fitted with a small shelf. This will become the altar place where we will remember and honor our spirit sister. Taking the cooled ashes, she puts half into a small hollowed out dried gourd and the other half into a small clay bowl. The Grandmother's quick fingers weave a rope basket for hanging the

gourd from the top of the board. This is the essence of the dead woman that goes out on the winds of the four directions, back to the Place of Spirit. The Grandmother fits a lid onto the clay bowl and sets it on the shelf. This is the essence of the dead woman returning to the Womb of the Earth Mother.

Another photograph of the woman is pasted onto the board below the gourd. Her birth name and spirit name are written below the picture in a fancy script. Since we put all of our memories and the symbolic essence of the woman's life into the cornhusk hut, we will be able to keep her transformed spirit on this altar to remind us of our connections with her. If we perform this ceremony for a Grandmother or Grandfather that we have never known, the honoring ceremony will awaken our connections to them and we will be able to keep this link through the memory board altar.

The altar becomes the home of the spirit shadow of the person as we have known him or her during their life. While the spirit returns to the Great Womb to transform and begin a new cycle, the shadow or memory of the spirit stays with us as long as we honor and remember its presence. Through the shadow spirits, we can communicate with our Ancestors and remember their wisdom. This is the part of our Ancestors that always remains with us. We shake our rattles one last time to call this shadow spirit home.

The ceremony is over and each person takes a flower from one of the vases to remind us of our spirit sister. We allow the white candles to burn all the way down, leaving the Earth Grandmother to stay and see the process completed.

The family of the spirit woman takes the memory board home to hang in their house with the other memory boards of their Ancestors. Usually there is a wall where the memory boards are kept that is accessible to all the family members. Sometimes, on special holidays for honoring our Grandmothers, the women bring the altars to the Women's Lodge, so that the spirits of the Grandmothers can be present for our ceremony. These spirit homes represent the presence of our

Ancestors and are always regarded with complete honor and respect. When we want to speak with or sing to the spirits of our Grandmothers and Grandfathers we can go to these altars. Burning candles and sage will carry our thoughts out to the spirit realm to reach them. We can share with them the happiness and excitement or the sorrow and loss of our lives. We can offer gifts and flowers to these Ancestor Spirits, and in return their voices will come to us in our dreams and everyday lives to bring us guidance and healing wisdom. *All we need to do to receive the wisdom of the Grandparents is ask.*

The spirits of our Ancestors remain with us long after their bodies have returned to the Mother's Womb. Their wisdom is the experience of all who have lived before us, and through their guidance we can find the answers to the difficult situations we are faced with at this present time. The Ancestors teach us to honor the Earth Mother, and our sisters and brothers. They speak of living gently and peacefully. They ask us to continue to remember them in the years after they cease to walk beside us.

PART FOUR

SONGS OF WOMB HEALING

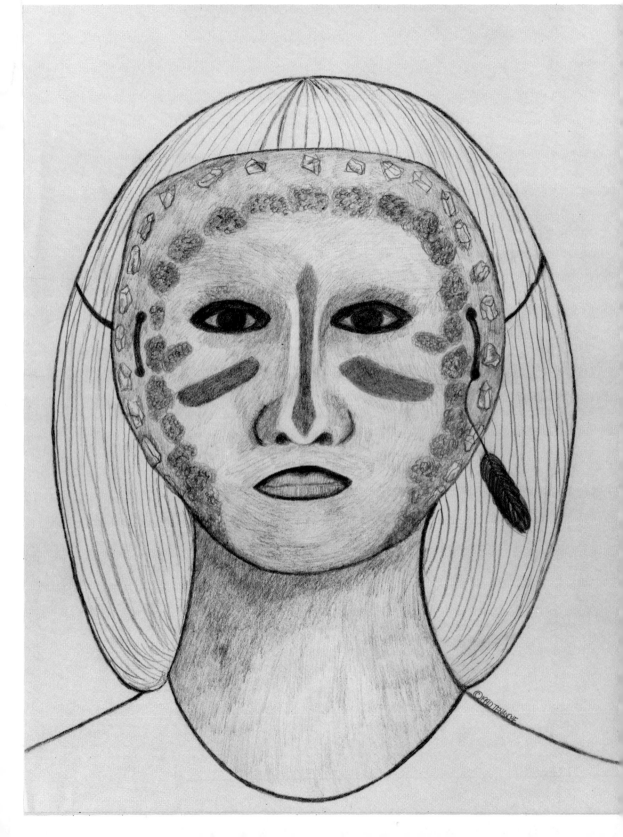

SONG OF THE BEAUTY WALK

I am a beauty spirit
bringing beauty to the world
finding beauty around me
everywhere I go
and living beauty each day.

Like the trees, flowers, rocks
and all of the Mother . . .
I let my beauty shine
all the time
in everything I do.

That is my purpose,
to give beauty and appreciate beauty.

I give beauty to all
and if they do not see my gift
I give it anyway.

If but only one person comes by
in my life who sees my beauty
then my purpose is made complete
in that one moment of sharing beauty.

SONG OF HEALING

Come now sister, and let me share with you the ways I have found to heal my womb. We have already talked of honoring ourselves and celebrating our womb cycles. For many women, these simple ceremonies and loving attentions are all that are needed to bring our monthly womb cycles into harmony with the rest of our reality. But, some women have many layers of social programming, pain and abuse that must be gently healed on physical and emotional levels before their wombs can begin to relax and flow with the rhythm of the universe. For these women, the Mother gives gifts for healing and bringing each woman's womb back into balance. Trust in her gifts and your own ability to renew yourself.

You are what you think. As manifestations of the Earth Mother, we are the creators. Not only do our wombs have the ability to create new life through children, but our thoughts create who we are and the situations we bring into our everyday lives.

Thoughts have form in the dimension of energy. Each time we create a thought, we create an energy form. Eventually, these forms collect and become attitudes. They ride in the energy field that surrounds our bodies. These attitudes begin to affect future thoughts and then our words and actions.

180

After a long time, repeated thoughts begin to make an imprint on our bodies. Even if we are not consciously aware of creating a specific thought form, we can feel the effects of out of balance, unloving thoughts as they press corresponding parts of our bodies into symptoms to attract our attention. When this occurs, when we feel dis-ease (not comfortable with ourselves), we are experiencing physical manifestations of our thoughts. In this case, the negative, unloving thoughts collect until they become strong enough to manifest as physical pain. It is just as easy to create positive, loving thoughts about ourselves which will manifest as health and well-being. Illness and disease are simply lessons from the Trickster that remind us to give ourselves attention and to focus our inner thoughts.

Just as we communicate with others through speaking, we also communicate in the energy dimension with people we are close to. Our attitudes can be greatly influenced by our teachers and parents, the information that we are exposed to through the media, and the influence of our peers. Energy can also be intentionally or unintentionally transferred from us to others or from others to us. We can pick up feelings and emotions from others which can energize us or even drain away some of our energy. Like words, energy can be easily moved. Thoughts, words and energy all go out to affect others with whom we come into contact and eventually the collective consciousness itself.

Energy forms from each one of our thoughts are sent out by us, whether we realize it or not. Thoughts and attitudes act like magnets to attract situations and people of similar vibrations. What we send out actually does come back to us as the kind of people we meet, the quality of our relationships and the opportunities and stability of our lives. What we think of ourselves also comes back to affect our bodies. Anger, hate, and fear create illness and pain, love and trust create health and inner peace.

Our thoughts and our energy gain momentum once they go out and we often get back much more than we had consciously or unconsciously asked for. Throughout each day of our lives, we are sending out

thousands of thoughts that work together to create our own unique version of reality.

This is how it works. If we think that our monthly bleeding cycles are a curse, then we will be sending out energy to create this time as a dreaded experience full of pain. We will find ourselves plagued with physical discomforts and a negative self-image in the days prior to the start of bleeding. For many women, these symptoms of "the curse" manifest fears and insecurities projected on us by the collective attitudes of society. For some women, these symptoms reflect anger and hate that have been stored up from past painful experiences involving our wombs, our sexuality or our self-image as women. By giving ourselves permission to believe the ideas of others or to hold responsibility for the actions of others as a part of our personal reality, we can make our bleeding times as awful as we perceive this "curse" to be.

The behavior of those around us reflects the beliefs that we have about the "curse," and eventually these beliefs are assimilated back into cultural attitudes and reflected in customs and social teaching, as well as accepted social interactions between men and women and among women. This is the process through which myth becomes reality. As you can imagine, each time these ideas come back around, another aspect of their meaning is defined and a firmer base is established within the evolution of culture. This is how premenstrual syndrome has become a reality for thousands of women in one culture while it is virtually nonexistent in other cultures where these thoughts/energies do not exist. In a very real sense, we have brought this "curse" upon ourselves.

No one particular situation or set of ideas or energy has the power to keep us limited unless we want it to. All we have to do is change our thoughts and energy forms to create a more healthful, loving environment. Every woman has the power to make changes in her life this way.

Now, suppose we begin to think of our bleeding cycle as a

sacred personal holiday. We put our energy into creating rituals to honor this time, we set aside time and space for ourselves, and we give ourselves a special gift each month. In whatever ways each woman can work a bleeding celebration into her schedule, we all can acknowledge this time as healing and positive. We give ourselves plenty of personal time to create a womb space and listen to our inner selves. We begin to use this time for personal assessment and connecting to the Earth.

At first, these new attitudes feel different from what we are used to, different from what we have been taught. Our pain and discomfort may not be transformed during only one celebration. But, honoring ourselves makes us feel good, and taking time away from outer responsibilities allows us time to heal. As we begin to let go of "the curse," we become more relaxed about our womb cycles and experience less pain and moodiness. We begin to look forward to our blood times and even feel empowered by them. As we begin to recreate a positive attitude towards bleeding, we open up to the Spirit Wisdom and ancient teachings that bring about a balance of body, mind and spirit. Our wombs, and our lives, reflect the healing power of our blood times.

The purpose of the Ancient Bleeding Lodges was to honor bleeding women as physical manifestations of the Great Earth Mother and to allow for a space to communicate with the spirits. Bleeding women enter the Spirit Realm and can bring healing and wisdom back to the people. In ancient times, women were honored by the communities for this special gift. As women begin once again to honor their blood cycles, these attitudes and energies will go out to affect the cultures of our daughters and granddaughters.

One by one, as each woman releases the myth of "the curse," we come back to the truth path of Spirit Wisdom. From there we reconnect to the Womb of the Mother as daughters returning to hear her wisdom. Healing ourselves, our sisters and the Mother herself is entirely possible within this space.

Letting go of the energy of "the curse," we also release the pain that has been brought to our wombs by invalidating our sacred gifts. We

simply stop believing in these limitations to be able to step into our birthright as women. We envision ourselves living up to our fullest potentials and allow ourselves to accept our abundant gifts. We are manifestations of the Great Earth Mother, and we *do* create the reality of existence. The power and wisdom we can find within our twenty-eight day bleeding cycle can heal and reconnect all life on the Sacred Web.

Use your bleeding cycles as a time to check in with yourself. Take off a day, a few hours, or even ten minutes, if that's all you can spare, and spend that time by yourself, no distractions, speaking and listening from your heart and your womb. Learn how your body signals discomfort and how to interpret its messages. Take a look at the energy forms, thoughts and attitudes you are carrying around, assess your needs, and make changes. Look into a mirror and honor yourself out loud. Be sure to say all those wonderful things you are hoping to become, as well as thanking yourself for who you are now. Focus your thoughts towards becoming the person you want to be and creating health and positive growth in your life. Know that you are a manifestation of the Earth Mother.

Each bleeding cycle is an opportunity for a new beginning. Starting again on the Medicine Wheel from the South, the opportunity is created for releasing the old, outgrown forms, and accepting that which we want to come to us. As our personal energy changes, it will be reflected in our relationships with others, and eventually a more positive attitude toward bleeding will be reflected in social customs. The return of the Bleeding Lodges will bring about individual healing for women, a change of social attitudes and planetary balance for our Mother Earth, as we return to her Sacred Space during our cycle.

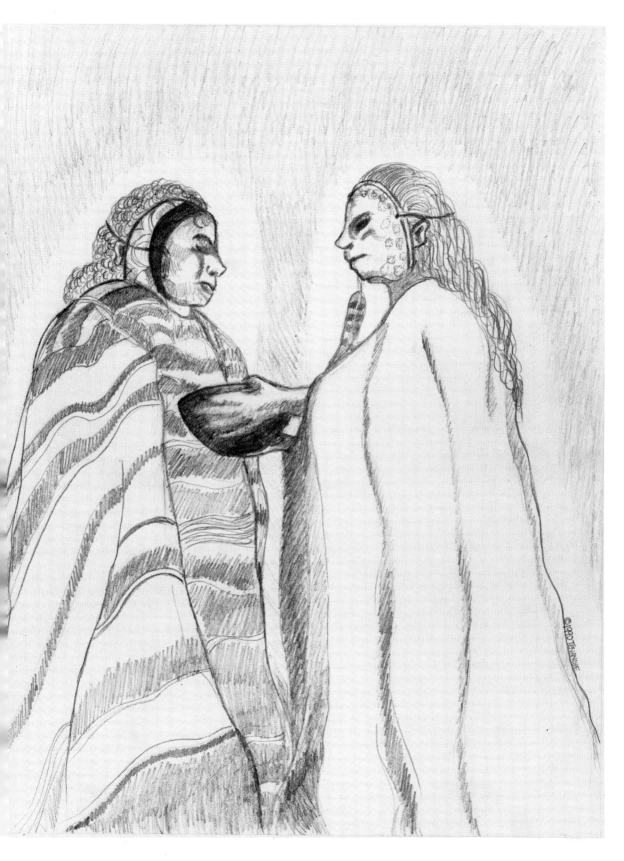

SONG OF THE HEALING DANCE

It is the sacred time when the Moon's cycle opens up the power within our wombs. As our womb bloods flow out between our legs and down into the Earth, we are reminded of her bounty and our need to give thanks. Knowing that all healing must be based in gratitude and also knowing that as we honor the Earth Mother, we bring healing to her, as well as to ourselves, the women begin preparations for the special healing dance.

The women know when the time for the healing dance is drawing close. We feel the rhythm of the Moon speaking to our wombs each cycle, and we know when the periodic renewals are needed. As the Earth Mother gives us our lives, our food, and the beauty around us, we must give back to her to complete the cycle. We do that in our Bleeding Lodge ceremonies and through the healing dance.

Everything is prepared in a sacred manner. Twenty-eight shells surround our circle of dancers and four blankets are spread out, one in each direction, holding the medicine objects of that direction to make our Medicine Wheel. Each woman brings her own objects to place on the blankets and share with the others for meditating on and connecting to the Earth Mother during the dance.

The shell calls to the four winds, and the women gather at the Lodge. Greeting each sister, mother, grandmother and daughter, we

weave our web as family. We feel the Earth Mother under our feet and know that we are never alone.

I always feel very special when I dance the healing dance. The anticipation of our spirit song runs high through my veins to every part of my body as I tie up my moccasins. The Elders are already beating their drums, calling the circle to come together. By the time I get there, the dedication has already begun.

"I dedicate my dance for peace among all nations on Earth," one woman states as she puts her gift into the Grandmothers' basket, and a pinch of tobacco into the bowl of the pipe. Around the circle, each woman and girl speaks to dedicate her give-away of energy through this dance by directing her intention back to healing a specific aspect of the Earth. By the time the basket gets to me, it is already very full. I dedicate my dance to healing the Sacred Tree of Life. As I smoke the pipe, I honor the Grandmothers for the wisdom that I know they will give us today. These are the last words that are spoken in the circle. We begin the chant that takes us to the Spirit Place.

The Food Mothers, with their masks and baskets, lead the women in a dance of simple steps upon the Earth. We form a circle flowing around the drumming Grandmothers sitting on their blankets. The vibration of healing surrounds us all in a womb-like cloak of harmony. We dance around and around the large circle. The steady beating of the drums leads the way to the spirit path. I settle into this rhythm and slowly let my body awareness give away until I become the movements of the dance.

Green cape, Black Bean Mask, and a small girl carrying a rattle dance by my eyes. Drumbeats . . . chanting . . . spirit cries and the voices of the Ancient Ancestors flow through my ears. Harmony flows into color. My feet echo the heartbeat of the Earth. My sisters transform into spirit dancers, each soaring within her own rhythm. Light outside the windows softens slowly into darkness. The Owl Spirits come to keep watch outside our Lodge.

As I dance, I listen to my Grandmothers speak the wisdom of the

ages. *"Listen. . . ."* they tell me. *"Listen to the heartbeat of the Earth. Feel her changing cycles, and know that you too are changing. You are about to leave your cocoon. . . ."*

Flowing through the dance, I feel my arms sprouting large feathers. My feet have left the floor and I fly effortlessly around the Lodge within the shell circle. On the steady beat of the drummers, I soar upwards, gliding on the energy that we have created.

When I open my eyes again, I am looking down at the Earth surrounded by a dark cloud, her colors faded and choked by an oppressing darkness. As I watch, I see rays of light coming to the Earth from out in space, surrounding and protecting her, weaving a web around all of the darkness. The light webs become anchored in the Earth through the trees and energy flows into the Earth, all the way to her Womb, and back out again. She begins to strengthen. The darkness slowly dissipates. Bright blues and greens return. I can feel the pulsating vibration of the light webs keeping the Mother in her steady orbit.

As the energy web strengthens, I can see it both inside the Earth, as well as surrounding her. The energy web becomes the roots of a giant tree that spreads out under the entire Earth. It is the Tree of Life. I can see the tree starting to strengthen and grow again, as the roots pulsate with new vitality. The trunk grows thick shields of bark and reaches upwards, growing back home towards the stars. Leaves and flowers bud and bloom on the branches. Birds return to drink the sweet nectar and animals come to sit under the shade of the branches. Outwards and upwards, the branches grow to encircle all the clans of Earth children. The people once again come to join hands and dance to honor the Sacred Tree.

I shed my wings to join hands in their circle, sharing my voice to honor the Great Tree. All is good. The Web is connected.

As the dance continues, I see the faces of my sisters around me and we are spinning the Web with our dancing feet and the music of our rattles and drums. All night we weave our magic. The slow-

ing rhythm softens the dance into a trancelike journey and then becomes vibrant again as the first rays of sunlight come streaming through the windows of the Lodge.

The Elder Grandmothers set down their drums and join our circle. The dance is silent for a short while as we listen to the harmony of the Earth. When we finally sit down, each one of us has internalized the rhythm of the dance into the very core of our beings. We each pulsate with the healing that the dance has brought.

After a while, we begin to speak our gratitude. Other women have had visions also. As we share the breaking of the fast, each woman will speak her story of Spirit Wisdom learned through our dancing. In hearing each others' stories, we know that our energy and intentions were felt by our Mother Earth. Like the trees outside the Lodge, the birds and small animals and the Earth underneath our feet, as we make our separate ways home, we too are renewed by the blessings of our spirit dance. The healing cycle is complete.

SONG OF THE HEALING PLANTS

Our Mother the Earth gives us all that we need for nourishment and good health. The food we eat and the plants that bring healing and balance to our bodies are the many gifts that she gives to us unconditionally, season after season. Just walking through our own back yards, we are reminded of her fertile abundance. Even if you live in a city, my sister, do not doubt that all of those ever-present weeds contain all the healing that you and I will ever need. They are jewels, precious gifts, to help us maintain a balance of body, mind and spirit. Honor all plants wherever you find them. Listen to the wisdom they speak to you, for they have much to share.

My grandmother was a woman of the plants. She loved her garden and was happiest on a sunny day, under her big straw hat weeding between the rows and sharing in the stories of plant wisdom. From the plants and trees she learned much. They told her of their gifts, when to harvest them and how to prepare extracts of their healing essences so that as much of their magic as possible could be retained.

Grandma did not stop just at speaking to those plants that she lovingly cared for from seed to flower in her garden, she was friends with all plants, everywhere... When I walked with her on warm summer evenings through the fields, she would introduce me by

name to the leafy green and brilliantly fragrant inhabitants. If I listened real hard, my six-year-old ears could just about catch their musical laughter. My grandmother would smile, knowing that I was also to be a woman of the plants someday.

My grandmother knew all of the plants. Folks would call upon her when they were out of balance and she would know exactly what plant preparation they needed. She would go into her magical pantry and stop in front of the neatly labeled tins storing the dry herbs and just look and feel the air. Then, she would walk back to the shelves of amber jars with the tinctures, listen and mutter to herself. Next to the shelves of tinctures were the creams and salves and oils, vinegars, and lotions. Sometimes I would see her peek inside her big old doctor book for a very special recipe. But mostly, she just looked and muttered and felt the air, and then she would reach up on one of the shelves and that's what she brought out. She was always right.

When winter brought illness and weakened our bodies, Grandma was always ready. She never turned anybody away. Her kitchen was the most interesting of places, as the drying herbs and warm, luscious odors soothed the spirit as well as providing a playground of wonder for a young child's imagination. It was here that the women's wisdom was passed down. The teachings of the plants and their healing gifts in this kitchen were as much a part of the Women's Lodge as the sharing around the campfires were to the Women's Council of our Ancestors.

"The women are the keepers of the plant wisdom," Grandma would tell me. "Women, like the Earth Mother, know the power of the cycles and the right times to plant, harvest, and prepare the plants. We know the same language as our plant sisters and brothers because it is the same language as our womb-cycles. There is not a plant on this Earth that can't become your friend and healing ally."

Grandma would tell me stories of when she was a young girl. People back then mostly relied on plants to sooth their ills. Doctors were few, and prescription medications almost unheard of. As our Ancestors had done for centuries, Grandma's family utilized the wisdom and heal-

ing of the plant gifts of the Earth for survival. "We ate the proper food for each season, and healing herbs were available all around us," Grandma recalled. Just as she learned the plant secrets from her mother and grandmother, she passed them along to me. "It's your birthright as a woman to know the plant medicine," she would say to me. Every time I catch the aroma of drying herbs or a warm herbal brew, I thank my grandmother for being the Herbal Grandmother and passing her teaching down to me.

When I started my menstrual bleeding cycles, Grandmother taught me about the women's herbs. She said there were a few plants that had special gifts for women. Because our wombs cycle and these plants know the cycle, they are beneficial in helping our wombs maintain their rhythm. If you walk through the garden with me, my sister, I will share the usage of these women's herbs.

The common vining plant that grows up along the fence there is one of the basic women's herbs. That's right, the same plant that gave us the ripe red raspberries to fill our baskets in early June has healing to bring to our womb cycles. Grandma told me to take some of their fresh or dried leaves and make a strong tea to drink every day. This helps your uterus to relax into her cycle and become strong and healthy. Red Raspberry leaves (*Rubus idaeus*) are mild enough to be used by women the entire duration of pregnancy, and indeed, are an excellent preparation for birth. When your uterus is functioning strong and healthy, those uncomfortable premenstrual feelings of bloating will disappear and you will also probably find that your bloods come with less cramping.

I drink a cup of Raspberry leaf tea every morning. Aside from the benefits of keeping my uterus in shape, this plant provides vitamins A, B, and C, as well as calcium, phosphorus, and potassium.

Be careful if you harvest your own leaves though, as the Red

Raspberry vine is full of protective thorns. **If you harvest this or any other plant yourself, please be certain of proper identification. Use a reliable field guide and make certain that you harvest at least fifty feet from the nearest roadway.** This will help eliminate toxins from automobile exhaust that can be absorbed by the plants and passed on to you. If harvesting your own plants sounds too difficult for you, there are many places where dried herbs or herbal products can be purchased.

My grandmother taught me to sing to the plants when I harvest them, and always to ask their permission. Sometimes I take offerings from my medicine bag to leave in the fields for the Plant Spirits so that they will grow more abundant next year. And, of course, I never take all of the healthiest plants, nor do I take all of the plants in one area. I remember Grandmother's teachings well . . . to take only what you need, leave the healthiest plants to seed next year's growth, and always leave some for your sisters and brothers who live here. There . . . now that the Raspberry vine has given us some leaves, we will thank her. Plants gathered in this sacred way will bring this harmony into your body and spirit, when we use them later in the kitchen.

Look here! Growing at the base of the fence are some other healing plants that have special gifts for women. This plant with opposite dark green leaves is the Stinging Nettle (*Urtica dioica*). Be careful, the Nettle stings if you approach her without respect! She has tiny hairs that carry a substance that is irritating to the skin. I've found that, if you sing to her in an honoring way, she will give away gently without stinging. These hairs become soft in the process of preparations and allow us to use the many gifts of the Nettles without discomfort.

This plant is a storehouse of vitamins and minerals, and is especially high in iron and calcium. I like to think of the Nettles as the blood-building herb, because regular use, especially in the premenstrual part of your cycle, will promote general health, strengthen your immune system, and nourish your womb and circulatory system. These gifts

work together to prepare your body for the bloodflow of your Moon time.

Nettles also has a high vitamin K content. Since vitamin K is a blood clotter, using Nettles during times of heavy menstrual flow will help slow the flow of blood so you don't get too drained. This herb is especially helpful in regulating bloodflow in women who have heavy periods, so that their bloodflow becomes less traumatic to their systems. Nettles is a diuretic, so drinking Nettles infusion or tea will help to pass liquids through your body quickly. This may be especially helpful to eliminate premenstrual bloating, but be cautious not to overindulge and cause stress on your kidneys.

This was one of my grandmother's favorite plants. She used the Stinging Nettles for everything from diaper rash salve to hair rinse to releasing premenstrual discomforts. Because of her special love for the Stinging Nettles, I think of her each time I stop to talk with them. . . .

Right here beside the Nettles grows my favorite women's herb. Motherwort (*Leoncrus cardiaca*) is a member of the mint family. See the square stem and purplish flowers that are similar to the other mints? I've found this plant to be one of the most helpful in regulating women's cycles.

Grandma taught me that Motherwort is the keeper of the rhythm of Moon cycles. Because of the action of this herb on the female hormonal system, daily use will bring regularity to your cycles, whatever number of days is regular for you. When your cycles are functioning in their own rhythm, the premenstrual hormonal imbalances will go away. Moodiness, depression, irritability and other tensions that occur before our bleeding times are symptoms that our bodies are out of balance. Sometimes our bodies are out of rhythm with our blood cycles, and we simply need a few days rest. Most of these symptoms, however, reflect a physical or hormonal imbalance, so using Motherwort tincture or infusion every day will help to eliminate these discomforts.

Because it is a mint, Motherwort, like her sister, Catnip, will help to relax uterine muscles. These herbs will help to bring on blood flow when you are feeling your uterus really full and ready to release. They will also ease cramping by allowing your uterus (and you) to relax a little as your blood starts to flow.

Because she knows the rhythm of your womb-cycles, Motherwort is also a healer for those women who need help regulating the blood flow changes that menopause brings. She works especially well with Dandelion root to even out hormonal changes and ease discomforts associated with "hot flashes." Mostly known by traditional herbalists as a heart strengthener, Motherwort gives her gifts to calm and soothe women during times of premenstrual tension and menopause.

This plant is the wise grandmother of women's healing and using Motherwort will teach your womb much about the rhythm of her cycles. Here, let's ask for a few of her leaves to take with us to put in our tea.

Walking along the garden path, I always take time to listen to the lovely music of the birds who come to visit and the critters that live in the stone wall and under the ground. Each of them play a special part in helping my plants to grow and I thank them every time I come here.

Look here, reaching up between the stones of the path and smiling at us with a radiant golden face is another women's healing plant, the common Dandelion (*Taraxacum officinale*). I remember going out with Grandmother all summer long to harvest the flowers and leaves to eat for dinner, and the roots in the fall to make tinctures. There were always Dandelion roots chopped up to dry and stored in jars in Grandmother's kitchen. She called it the tonic plant and said that it had gifts to help almost every ill.

Grandma's recipe for relieving menstrual cramps was an infusion of Raspberry leaves, Nettles, Motherwort and Dandelion root. These she would prepare in the teapot, in the kitchen, when I first started to bleed. Then she would encourage me to go spend time alone dreaming my

blood dreams. It always took a while for the womb drink to be ready, so I would sit and put my hands on my womb and talk to her for quite a while before Grandma would come back with a warm cup of Moon magic tonic. I always felt much better after drinking Grandma's special brew.

Dandelion roots and leaves are high vitamins A, B, C, D, and E. This plant is an excellent tonic for removing poisons from the liver and excess liquids from the body, a good thing to keep in mind when premenstrual bloating gets you feeling puffy. Dandelion tones the female reproductive system and can be used by women in all phases of Moon cycles, during pregnancy to build healthy breast milk, and especially during menopause changes. The gifts of Dandelion assist menopausal uterine changes by providing an abundance of vitamins and minerals to maintain good health.

Dandelion root also contains insulin which regulates blood sugar levels and helps to ease premenstrual swings of blood sugar imbalances. Although infusions and tinctures are wonderful ways to use this healing plant, do not forget that her flowers and greens, abundant for much of the year, make an excellent healthy food as well as promoting good digestion. Why don't we ask for some of those lovely yellow blossoms for our basket also?

Ah, the plants and trees here are so healing. It is the energy of the Earth and Sun that combine and, through their magical union, make possible the gifts of the plants that we have growing all around us. Each plant or tree has a specific spirit, its own energy. It's best to spend some time getting to know the plants and trees, if we are going to use them for our own healing. For, in addition to their physical gifts such as the vitamins and minerals they give to replenish our bodies, they give us energy to nourish and awaken our spirits. When we use a plant to eat or for medicine, we are in effect taking on the spirit of that plant so that it may live through us. When

we harvest the herbs, we need to be aware of the energy of the plants, so that we take only those that are nourishing for our own special vibrations.

Grandmother took me to the garden every day all summer long when I was a girl. Each day she told me to sit by a different plant and just listen to hear its voice. It took me a long time before I was able to hear and understand their subtle energies and vibrations. If we honor the plants and take time to listen, they have much to teach us. If we listen to the voices of the plants before harvesting them, we can take all of their wisdom, as well as their healing, into our bodies.

There are many plants here that speak of women's wisdom. Here in this section of the garden is the low creeping Strawberry plant (*Fragaria vesca*). Their fruiting season is about over now, but if you look, you may find a few last red berries under the dark green leaves. Grandma always had bowls of red berries and other red foods around when I was bleeding. "The red foods nourish the bloodflow," she always said.

During my premenstrual days, I drink a strong tea made of Strawberry leaves and Motherwort. The Strawberry leaves tone up your circulatory system, particularly the capillaries in your uterus. Women who have problems with excessive bloodflow will find this little plant a wonderful healer for establishing a more normal rate of bleeding.

Growing along the back of the garden there is another valuable women's plant, Yarrow (*Achillea millefolium*). Notice her umbrella of small white flowerheads above a branched stalk that has lacy dark green leaves. The small garden spiders love to spin their webs between the flowerhead stalks. Grandma said they gave their medicine to the Yarrow for it is a plant that weaves good health.

The Yarrow is an astringent and indeed works well when you are sick. Yarrow sitz baths, sitting in 4-6 inches of herbal water, helps relieve the discomforts of vaginal infections. Drinking Yarrow tea will help to bring down a fever and keep the infection from spreading or recurring. This plant is most valuable for her gifts of slowing down excessive bloodflow. I know of many women who have used Yarrow tincture to

slow down extra-heavy bloodflow during the first day of their cycle or after childbirth. Grandma always had lots of dried Yarrow hanging in her kitchen. She said it was her "first aid" plant and never left the house without it when she was going visiting.

As we walk back to the house, here are two other plants that I would like to share with you. This one here you might recognize. That's right, it's Catnip (*Nepeta cataria*)! See its square stem? It's a mint also. This plant has mild healing properties that make it as much a favorite of mine as it is for my cat. The calming effects of a warm cup of Catnip tea is the remedy I prefer for premenstrual jitters. Catnip also soothes upset digestive systems and helps relax both nerves and muscles, so that you can sleep easier. Warm Catnip brew is a drink I recommend to women who are feeling crampy to help relax uterine muscles and encourage bloodflow. Let's take a few leaves back with us for our brew. You do the asking this time!

This large, dark green leafed plant is Yellow Dock (*Rumex crispus*). It's another of those weeds that has healing gifts that you can find growing wild in your yard or unkept sunny places that has healing gifts. Grandma and I would harvest the roots of Yellow Dock in the fall to put up tinctures. She always said Yellow Dock was the plant highest in iron and encouraged me to take a few drops of Yellow Dock tincture daily in the winter, when fresh greens were unavailable. Grandmother taught me that iron was very important in my diet once I started bleeding, so I continue to use this special plant with its valuable gifts.

Now that we have returned to the kitchen, we'll put these herbs into a tea pot and put some water on to boil on the stove. Today we'll just be making a tea to enjoy the flavor of these plants, so we'll only need to steep them a short while. But, when you go to make your menstrual bleeding preparations, you should let the herbs steep for two to four hours, so that the maximum of their healing

properties are extracted by the water. These herbs are volatile and you can warm your preparation up before drinking but don't boil it, as you'll lose their healing gifts. The resulting brew will be strong and tasty.

If you want to make an even stronger, more concentrated preparation of herbs, you can make a tincture. If I use fresh herbs, I'll fill a jar to the top with plants or flowers, and then fill the jar with vodka or brandy. If fresh herbs are unavailable and you are using dried herbs or roots, fill the jar about half with plant materials, then fill with alcohol. Always put a piece of wax paper between your tincture and the lid of the jar. In a few days, I return to refill the space at the top of the jar where the alcohol has been absorbed by the plants. "If there is an air pocket in the jar," Grandma always said, "it won't tincture properly."

Sometimes I let my tinctures set for six or eight weeks, sometimes longer. The longer they set, the stronger the concentration of healing properties the alcohol extracts from the herbs. Just like the water preparations get stronger the longer you let them set.

Here are some tinctures I've made in the last few weeks. I keep them in the pantry, out of the Sun. You can notice the ones that have been setting longer by the richness of their color. I've put the date of the tincture on the lids so I will remember exactly when I made them. When the tinctures are ready, I will strain them off through a mesh basket and pour them into labeled amber jars for storage. If I need concentrated amounts of herbs, or in the winter when fresh plants are unavailable, I will have tinctures to use. Tinctures retain their potency for years, and are easily carried in your bag to use in places where making a brew is not possible.

There, it looks as if our tea may be ready now. What do you say we take our cups and some of this fruit out to the patio, so that we can enjoy the garden while we chat? Perhaps now, my sister, you will share some stories about your own Grandmother's wisdom. I would love to hear them . . . Let's go!

PART FIVE

SONGS FOR A NEW WORLD

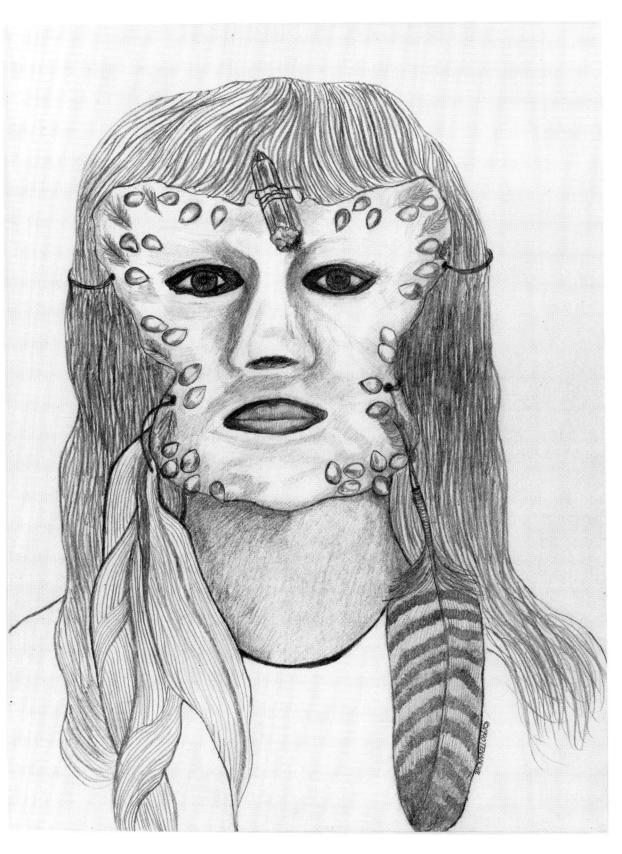

SONG OF THE ANCIENT GRANDMOTHERS' AWAKENING

Children dancing in time
We have not forgotten
The voices of the Ancient Ones
Are with you everyday

Spinning and creating life
You soar into the future
The Golden Door has opened
Into another age

We come with you
The voices in the trees
As are your Ancient Grandmothers
The rocks, the winds, the sea
Sing our healing chants

We sing inside of the Earth
We sing inside of your wombs
As the Fifth World turns to harmony
And the balance of love is restored

The Ancient Ones have returned
Our messages are clear
For each of our daughters
Is a precious jewel
Carrying forth magic into the new world.

SONG OF THE EARTH CHANGES

As we grow and change, so does our Mother Earth. She has her cycles just as we have ours. The short cycles of the Moon and her effects on the tides of the sea, the long cycles of the Sun and his effects on the growing plants and animals are the familiar cycles that compose the vibrational rhythm of our planet. They are the heartbeat that we respond to.

But, the Earth also has larger cycles and these are the ages that we call the Worlds. These cycles contain a vast number of years and span entire evolutionary periods. As Mother Earth evolves and grows, she moves into new dimensions. She too needs to cleanse and heal as she grows. Her changes naturally affect all of her children, for we share in her energy and rhythm. All of the creatures on land and in the water, all of the birds that soar in the sky, all of the trees and plants respond to the heartbeat of the Mother's cycles. When the Mother's rhythm (or vibration) changes, all of her children feel her growing. This is what is happening with the Earth today.

We are presently in a transitional period, evolving from the Fourth into the Fifth World. The world as we have known it, has embodied all the concepts that were a part of the Fourth World. The polarity between male and female, differences between political and religious institutions and wars of power-over and greed charac-

terized the separation that was part of our past lessons of growth. The Fourth World reached its peak with the separation of humankind from nature. Ruled by attitudes of those men in power, the Fourth World encouraged the people to grow as far away from the rhythms of the Earth Mother as possible. This separation of us from our Mother Earth has resulted in the limitations of our present belief systems and misunderstanding of our purpose here on the Earthwalk.

As the Earth Mother heals from the wounds that we have inflicted upon her, we can feel her vibrations changing. The heartbeat rhythm quickens and we are called to change our beliefs and to free ourselves from the limitations that we have constructed from past lessons that are now hindering our growth. We must each recognize our purpose on this Earthwalk and make renewed commitments to our paths.

Each person is being called on at this time to heal the separation within. Women must accept and integrate our male aspects and men must integrate their female selves. All unresolved hatred, anger, fear, blame or guilt must be let go of and healed in order for us to move forward into the Fifth World. Our struggles at this time mirror the growth and healing of our Earth Mother. As we heal ourselves, our own vibrations will become clear and strong and this energy will support the Earth in her changes. Our personal rhythms will begin to correspond to that of our Mother Earth in a way never before felt. Thus, as we go through our personal healing, we heal the Earth as the Web of Life becomes re-energized.

Our Mother is birthing us into a new species at the present time. As her vibrations strengthen, we can feel ourselves changing with the excitement of knowing that our Fifth World grandchildren will be living within the circle of peace. The Fifth World brings harmony and is the time for the Circle of Clans once again to come together to dance under the Sacred Tree of Life. We look forward to the unification of the people, the blending of spiritual truths that honor the Earth Mother, the development of our talents of mind communication, the actions of each heart based solely on kindness and unconditional love. When we

emerge from our cocoons, we will take flight into our fullest potential.

During the transition period, healing ourselves, our communities and our Mother becomes a priority as the balance needs to be restored. It is very important to keep our thoughts focused on the world we are becoming, the circle of harmony, and not get caught up in the world we are leaving as the structures there begin to dissolve.

The medicine of the Moon Lodges is the guidance we have as we step forward into the Fifth World. When we remember the ceremonies and wisdom of our Grandmothers, we build a bridge into the future. When we connect to the Earth Mother as women during our blood cycles, we can heal any limitations or separations that need attention in our own evolution and growth. The healing of each woman reflects a powerful reawakening of Earth connection that is felt by the entire community. This is the first important step in healing during the transition, for the Earth and her children evolve together. The Medicine of the Bleeding Lodges awakens the truth within our wombs. It is here that we communicate with the Ancestors. All of the answers to all of our needs are found when we look within during our bleeding times. As the Women's Lodges of the past were sources for healing and counsel, now they become the places to teach the wisdom to help us build the future.

As we grow into the Fifth World, we each find the truth within. We know what to do according to our own needs. The more Moon cycles a woman spends listening to her wisdom, the more empowered she becomes to create her own reality. We empower ourselves by loving ourselves and honoring our cycles. We recognize our womb wisdom as authority because we recognize the voice of the Mother as she speaks through our cycles. We have no fear, for we know that we have the wisdom within our blood medicine to bring about the reality of a new future. Women everywhere are working during their Moon cycles to create the harmony of the circle of the

Fifth World. Whatever you personally need during this time of transition, you can create too.

It is important for each of us to walk without judgement during this time. We are all changing and each is traveling at our own pace. During times of doubt, the Earth Mother will console us with her soothing harmonies if we take time to sit back to back with a tree and listen. The voice of the trees speak the sounds of the Earth, the new language, that of harmony and love.

We know that we have within our wombs the rhythm and vibration of the Universe. We know that our Mother is changing and we delight in her growth. We know that to honor our Ancestors and our womb-cycles will bring the medicine to unite again the circle of harmony on Earth. We are honored to be caretakers of the Earth Mother. Every woman is a healer, every woman a wise midwife creating the bridge into the Fifth World for all of our children.

SONG OF REMEMBERING

A Star
brightly shining above
sends out a radiant beam
to the Mother's heart. . . .
Earth Sister—
remember your star family
remember who you are
remember that your cycles
sing the harmony of the Universal Rhythm.

The Starbeam
is caught by the Moon
and sent down into the wombs of the women.
Sisters—
remember who you are
remember that your cycles
Sing out the song of the Universe.

Earth Sister,
Moonsisters—
come back into your wisdom
remember your song
honor the passages of life.

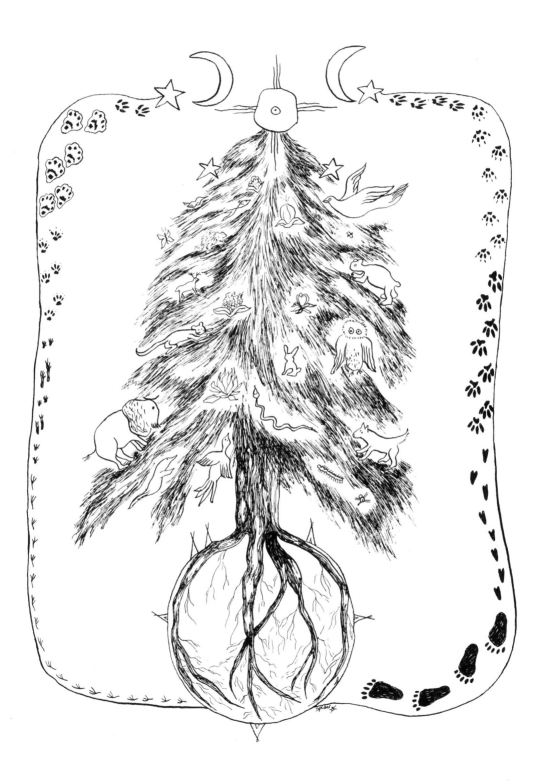

SONG OF THE SACRED TREE

The Tree of Life stands at the center of our world. It is a huge tree with a trunk many yards across. Her roots extend deep into the Earth, all the way to the Great Mother's Womb and the offshoots of the great roots intertwine to weave a lattice under the ground upon which all peoples walk. Creatures that live underground make their homes in the corners of the root lattice and are nourished by the connection of the great roots to the Sacred Womb.

The wide trunk of this Tree can cast a shadow over an entire village. Indeed, it would take a large circle of people holding hands to surround her trunk. The Tree of Life has been here since the beginning of the Earth. Her ancient trunk has grown into crevices where children play by day and animals dream at night. All of the distinctive folds and marks upon her giant trunk are a record of the events that have happened on the Earth. This Grandmother of all trees is very special, for she holds within the many layers of her rings all the wisdom given to us by our Ancient Ancestors and all the wisdom gained through the experiences of our grandparents.

Extending upwards, high up for miles into the sky are the great leafy branches of the Tree of Life. It is believed that her branches reach the whole way to the stars, and the Elders tell us that some of our original Ancestors made the long descent down the leafy

branches and furrowed trunk to make their home upon the Earth. Indeed, the tallest of trees connects the wisdom of the stars to the gifts of the Earth.

The great leafy branches of the Ancient Tree extend for miles, shading and cooling the Earth. Nests of many types of birds, insects and animals populate her abundant branches. For all of the Earth children, the tree flowers, grows fruits, and provides for all their needs.

People of all Earth clans once gathered every season to form a circle around her giant trunk and dance under her flowering branches because this Tree of Life reflects all life on Earth. She was respected and honored by all of our Ancestors of every ancient tradition. The songs and ceremonies in her honor were to thank her for her many gifts, and to ensure an abundance of life continuing on into the future.

The Ancient Tree is the keeper of energy and the home of the Spirit Ones. The Guardians reside at the depths of the great roots and the tops of her sky branches. From the beginning of the world, shamans have journeyed through the Great Tree to speak with the Guardians, seeking to bring their wisdom and guidance back to the people. This, the greatest of all plants, not only provides our physical needs but also the way to the healing and protection of the Guardian Spirits. She gives us harmony and balance, if we respect her. We all live under the branches of the Tree of Life.

The Grandmothers are the keepers of the Tree. The wise old women tend to pruning her branches when they lose their life energy, and they also take care of the plants and Earth that surround her giant trunk. They plant the sacred foods at her roots and bring offerings of plants and herbs from the first harvest of their gardens to feed her spirit.

The Grandmothers carry the sacred baskets that are filled with the wisdom and gifts from the Sacred Tree. They bring these gifts and this knowledge to the community for all the clans to share. And they take back our give-aways to the Tree, so that with our support she can continue to grow strong.

From the beginning of our world, we have lived within the har-

mony and abundance of the Sacred Tree. The baskets of the Grandmothers were always full. But, somewhere in time, the people began to let other concerns fill their lives. They took the shade and the gifts of the Sacred Tree for granted. Fewer and fewer of the people returned to the tree each season to dance and sing to her. Finally, they stopped giving away to the Tree as their gratitude was forgotten.

Now, at the beginning of a new world, the Sacred Tree is very sick. The bark is peeling from her once thick and healthy trunk. The fleshy, healing inner bark is beginning to dry up, as nourishment is choked off. The Sacred Tree can no longer give away the medicinal bark to the people. Many of the lattice roots are gone now, as poisons dumped into the water and buried under the ground have choked off their growth and the lives of many of the creatures who once lived within their weaving. As the small outer roots die, part of the land loses support from the Sacred Tree of Life. This land roughly shakes loose as the Earth quakes in her grief over the illness of the Tree. The Mother knows that the roots are our foundation of truth. She grieves because we are poisoning ourselves and our families. The great roots are still intact and the Spirits cry out messages from their depths. But, who hears their call, their urgent request?

The once great branches are thinning and many of them are now leafless. Flowers and fruits are fewer each season. The branches also suffer the effects from toxins, those we have released into the air. Winds that are filled with hate and destructiveness rise up from the place of the people and also contribute to the wilting of the branches and the leaves of the Sacred Tree. As the branches of the Sacred Tree become thin, more sunlight reaches the Earth and her creatures, creating a warmer environment. The atmosphere thins. Nothing can live without the shade of the Sacred Tree. Many of the birds, insects and animals that made their nests in her branches are gone and will never return. Many of her beautiful blossoms will never be seen again. But the way is still open to the wisdom of the stars. Will we

listen to this wisdom before these branches, too, are gone?

Perhaps the people have forgotten about the Sacred Tree. Perhaps we have forgotten that if the Tree ceases to exist, so do we. Perhaps the few of us who do look upon her wilting branches feel her pain, but do not know how to help her.

The Ancient Grandmothers are still caring for the Tree. They tenderly prune the branches and knead the bare Earth at her roots. The Grandmothers sing to the Tree while they work, and give her healing and love. They help the displaced creatures find new homes, but only sometimes are they able to heal their hurts. Although they have kept the Tree alive until now, the Grandmothers cannot bring back her beauty without the help of the people. They patiently wait for their grandchildren to remember.

The baskets of the Grandmothers are empty now. The Sacred Tree has precious little left to give to us. It is now time for all of the people to make give-aways so that the Tree can be helped and grow strong again. It is the responsibility of all of us to care for the Tree, to clean up the garbage around her roots, and to feed her to make her strong again. It is our responsibility to change the winds that destroy life by replacing all of our thoughts with those of love and kindness for all life, at all times.

When all of the grandchildren awaken to their connection as a family, the circle of the clans will once again come together to sing and dance around the Sacred Tree. When the people remember the source of their gifts, the Grandmothers will once again carry overflowing baskets to the Tree. If all of us do whatever we can to give back to the Sacred Tree of Life and speak to everyone we know to help them also remember, then, as we enter the new world, the Tree will be a pathway for us as it was for our Ancestors. The Tree will allow us passage into another world of great beauty and abundance. If we forget about the Tree and let her die, the way will not be open for us to enter the new world, and we will have denied the very lives of all of our grandchildren.

BLESSING SONG

Blessings upon you, my sister
Blessings upon you, daughter of the Earth
May you know peace and health
May your life be full and abundant
You are the form of the Earth Mother
Giving birth to the Sacred Circle.

Taino Ti, Sisters,
Honor and blessings on your Earthwalk.

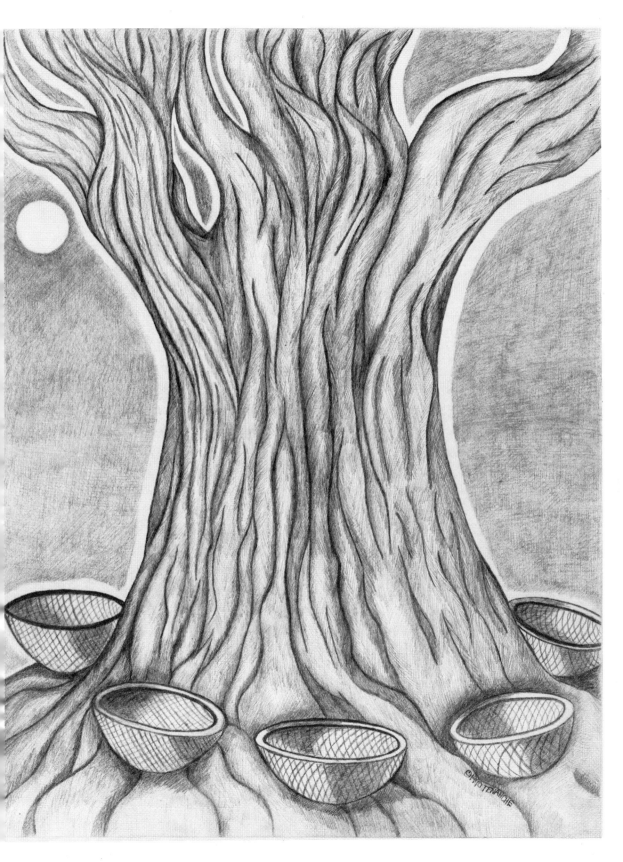

ABOUT THE AUTHOR

Spider is a teacher of Medicine Wheel Wisdom. This sacred spirit connection teaches a way of life in balance with the Earth Mother, a focus to honor all of our relations through ceremony, and a pathway to heal ourselves through using our gifts of birth to walk in Truth.

Guaba Guarikoku, Spider walking on the Earth, was the name given to Spider by her Guardian Spirit on her first vision quest. This name reflects her life path of reconnecting the Sacred Web of Life through the teachings of Earth Wisdom.

Spider is a ceremonial leader (Beike), pipe carrier and practitioner of healing ceremonies (Boitiu) in the Taino tradition. The Taino people live in Puerto Rico, Cuba and the Dominican Republic. These matrifocal people honor the Moon's cycle as a reflection of the fertility of the Earth Mother and honor women for reflecting the Moon/Earth medicine during their bleeding cycles. Spider came to this path through apprenticeship with the Caney Indian Spiritual Circle, a Taino spiritual group based in Pittsburgh, Pennsylvania.

As a Clan Mother with the Caney Circle, Spider carries the wisdom of the Women's Lodge. On a vision quest in 1987, Spider was given a directive by the Grandmother Spirits to share the teachings and ceremonies of the Women's Lodge, because the time has come for women to reestablish theses spaces to honor their cycles and reconnect to the Earth Mother. This book is the result of several years of writing down the Caney Circle Ceremonies plus other passage rites that were given to Spider in dreams, specifically to share in this book.

Spider is also a teacher with the Wolf Clan Teaching Lodge and shares the Medicine Wheel teachings of Grandmother Twylah Nitsch.

Throughout her travels, Spider has been working with women's groups to assist them in creating their own Bleeding Lodges and to teach them the passage rites and ceremonies to honor their blood cycles. Spider and Cathy Minor have made a tape of the songs from

216

the Women's Lodge ceremonies entitled *Songs of Bleeding*, available from Data Data Publishers, P. O. Box 534, Santa Margarita, CA 93453.

Spider is available for workshops and can be contacted through Black Thistle Press, 491 Broadway, New York, NY 10012, (212) 219-1898.

ABOUT THE ARTIST

Tenanche Semiata-Akuaba, is a Clan Mother, a Beike (ceremonial leader and pipe carrier) and a Boitiu (shaman) of the Caney Indian Spiritual Circle. Her formal education and training include a B.F.A. in Painting/Spanish and an M.A. in Art History/Latin American Studies. Her name means: "I am the Life-Tree, Mother of the Spirits, Symbol of Fertility" in the Maya Indian, Taino Indian, and Ashanti-Yoruba languages. She has lived, studied and taught in Mexico, and through her spiritual work with the Caney Circle, shares her knowledge and experience of the culture, art and spiritual traditions of the native peoples of Mexico and Central America. She believes that sincere understanding and practice of the enduring wisdom of Earth-honoring cultures is essential to our returning to balance and harmony within ourselves, with one another and with the Earth Mother.

Tenanche is a member of "Women of Visions, Inc.," a Pittsburgh-based women's art collective, has exhibited widely, and her paintings are included in collections in the United States, Mexico, and Costa Rica. Interested particularly in creating native goddess images and self-portraits, she uses these images in ritual and healing work. She also works with quartz crystals and other healing stones. Tenanche can be contacted through Black Thistle Press.

ABOUT THE COVER

The painting on the cover, entitled "Reawakening, Remembering, I am the Life Tree: Te-nan-che," evolved as part of an ongoing healing process following a personal, physical and spiritual crisis in the life of the artist. She calls this "a universal self-portrait" symbolizing self-empowerment through an evolving awareness of the inherent power within all women to create life through the vehicle of our wombs. This by extension reflects the power of the Universal Mother, the source and nourisher of all life as expressed by the Earth's cyclical birthing, transforming and re-birthing of life forms. Thus, it is through the honoring of our connection with the Earth Mother that our transformation and healing take place.

ABOUT THE FOOD MOTHERS' MASKS

In every ceremony of Earth honoring in the Caney tradition, the four baskets of sacred foods sit at the four directions on the Medicine Wheel, inviting the Food Mothers to sit among us to share their teachings. During some ceremonies, women in the circle take on the persona of these Sacred Mothers and bring their blessings to all the people at the ceremony.

Throughout Spider's years of participation in Caney ceremonies, she began to see the images of the Food Mothers, each one taking on the foods and the wisdom of their specific direction and reflecting them back to the people in the circle. It has been through personal healing work that Spider came face to face with these four keepers of Medicine Wheel teachings.

During the process of shamanic initiation, healing skills are learned through a series of lessons provided by a person's Guardian Spirit. Through the process of trust and listening to Spirit Wisdom, the person is given her or his path of healing. All spirit healers and

true shamans must complete this process of self-healing before they can effectively pass their skills along to help others.

This process was difficult for Spider as she had been a professional artist and then found herself with severe visual problems. Unable to focus her vision or even read for long, Spider spent a lot of time listening to Spirit Wisdom and learning about healing energy. Her process took her into healing ceremonies that explored each of the four directions on the Medicine Wheel. During each ceremony, as she sang her Spirit song, the Food Mothers came to Spider and spoke the healing wisdom of that direction. Looking each of the Food Mothers in the eye, Spider saw the beauty and strength in their faces. Spider's process of visual healing included making the plaster masks that embody the images of the Food Mothers and Earth Mother.

These masks are used in the Caney Circle Equinox and Women's Lodge Ceremonies. They bring the presence of the Food Mothers into our ceremony as well as their wisdom and healing, especially for those women who wear the powerful mask images. Since the Food Mothers are a part of each women's ceremony, they are invited through the drawings of Tenanche to share their power, healing and teachings with those who read this book.

SONG INDEX

*These songs are on the audiocassette tape *Songs of Bleeding.*

219

SONGS OF BLEEDING AUDIO TAPE

A rich collection of songs and chants sung by Spider, backed by drums, voices, rainstick and sea urchin rattles that bring a special Moon/Sea energy to their purpose as Spirit callers.

The songs on this tape are sung during Women's Lodge ceremonies to honor women's bleeding cycles. Some of the songs are of Taino tradition as practiced by the Caney Indian Spiritual Circle. We sing these songs to honor the rhythm of the Universe inside of our wombs.

These songs came directly from Spirit and are composed by Spider, Miguel Sagué (Caney Indian Spiritual Circle), Celu Amberston (Corn Woman) and Grandmother Twylah Nitsch (Seneca Indian Historical Society).

My sister the Moon
Sings her song to my womb
We dance
In the Spiral of Life . . .

Available in stereo cassette tape. Includes all of the words to the songs and a description of the purpose of each song.

Produced by Cathy Miner and Spider
Recorded by Medicine Avenue Records
© P 1992 Data Data (Ascap)

Send check or money order for $10.00 + $2.00 Postage and Handling to:

Data Data Publishers
P. O. Box 534
Santa Margarita, CA 93453